Four Seasons of

Wildlife

Montana & Yellowstone

Photography by G. Vince Fischer

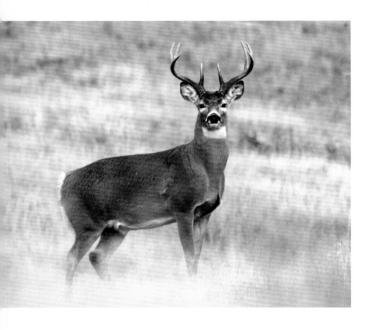

For the opportunity, pleasure and gratification of spending many hours over these many years with the animals, birds and waterfowl of this wonderful area of ours, I am truly grateful. Also for the opportunity of photographing the wildlife living here, allowing this book to happen, has been a pleasure.

Also for Suzanne, who has been a partner of mine for over sixty years. This hobby, or avocation of mine, has taken considerable time. For the many hours that she spent in vehicles and campers and for the days at home waiting for me, I am very appreciative. Thank you!

ISBN 10: 1-59152-079-7
ISBN 13: 978-1-59152-079-5

© 2011 by G. Vince Fischer

Cover photo: Male grizzly in Glacier National Park.
Back cover photo: Swan at Freezeout Lake.

You may order extra copies of this book by calling Farcountry Press toll free at (800) 821-3874.

Produced by Sweetgrass Books.

sweetgrassbooks
a division of Farcountry Press

PO Box 5630, Helena, MT 59604; (800) 821-3874; www.sweetgrassbooks.com.

Printed in China.

15 14 13 12 11 1 2 3 4 5

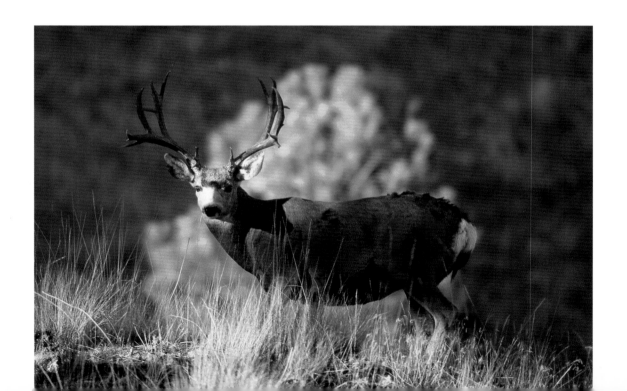

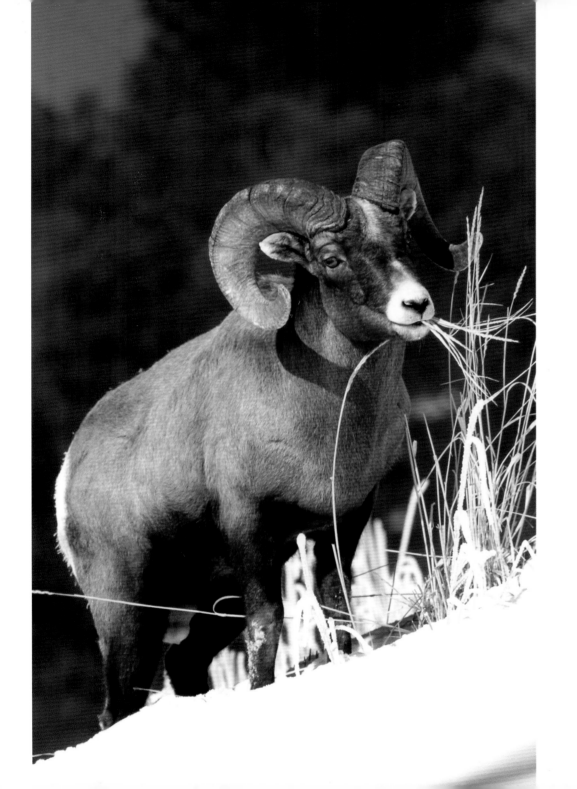

I HAVE MANY FOND MEMORIES of sights experienced while viewing subjects through the lens of a camera over the past forty years. This book is a reflection of those sights that are frozen in time through the miracle of photographic technology.

It was my thought that allowing those scenes to simply decay in slide trays and thumb drives would be a shame. My attempt, of course, is to pass those scenes on to you so that you may also share in the same ecstatic feeling I had when recording them.

This is not a story book, it is a photo book, and those subjects will tell a much better story than I could. There will, however, be some descriptive explanations, some identification and some comments of interest relating to certain images.

There are many photographs of subjects here that other photographers have recorded, some of them excellent beyond belief, but it is a fact that no two pictures of wildlife are exactly alike and it is hoped some of these will have a different and pleasing impact.

It was also my desire to, in my way, reflect the feeling of our four seasons. In my opinion, this part of our country is the greatest spot on earth. We just do not seem to experience the massive and catastrophic acts of nature that occur in other parts of the world. We do, though, have those four climes that phase in and out of one another, and each brings some excitement and anticipation of change. At times the Montana/Yellowstone area can be harsh, but certainly not boring, and it is never long before another welcome change takes place.

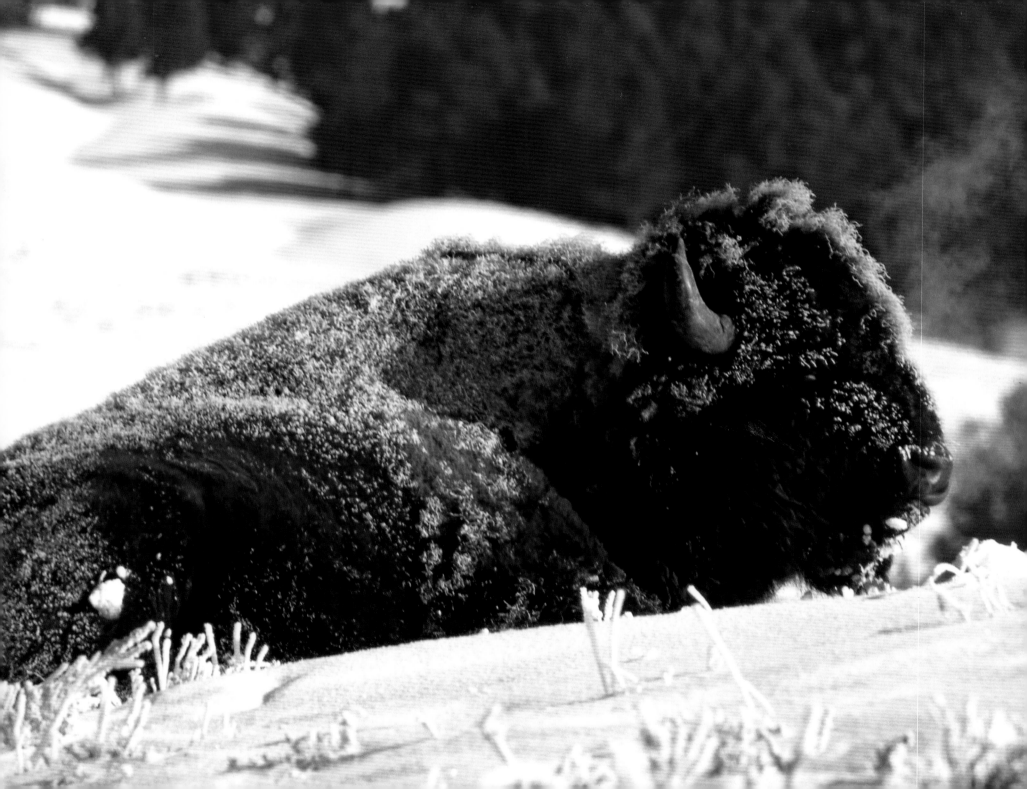

Winter

*Most of the animals
that remain are quite
sedentary to save
energy for survival.*

This is the "quiet" season of the year. The hush of deep snow on a cold day sets the tone, but beyond that, many of Montana's species have gone to bed. Some of those that quickly come to mind are ground squirrels, marmots, bears and reptiles. Hibernation is a long winter sleep, and to prepare for that, these animals spend most of the rest of the year putting on fat to sustain themselves for several months without eating.

Other animals and birds that don't hibernate have left, as is their custom, to migrate to warmer climates, and finally, most of the animals that remain are quite sedentary to save energy for survival.

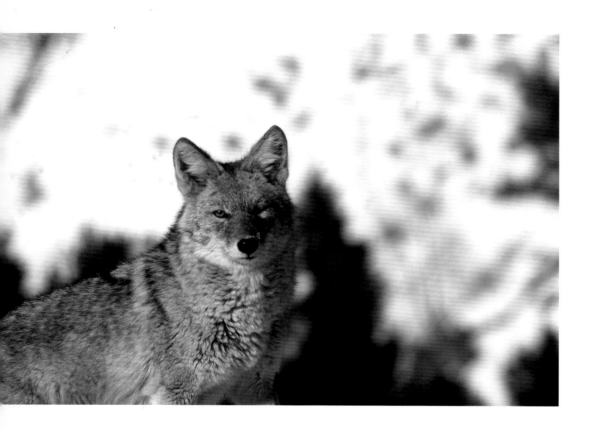

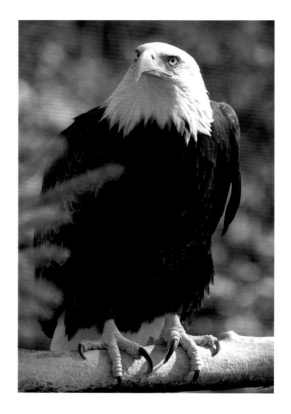

There is an exception, however, to this inactive season and that is the lifestyle of the predators. This could very possibly be their most favored time of year. Not only is prey more susceptible but also more carrion is available from weakened animals that have perished due to the harsh winter. In addition, this happens to be the mating period for both canines and felines. Another class of predator that hangs around during the winter are raptors. Several species of hawks remain, but our national bird is here for only a short period, then comes back in time to find someplace where fish are spawning.

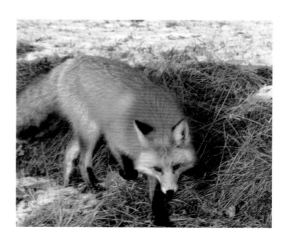

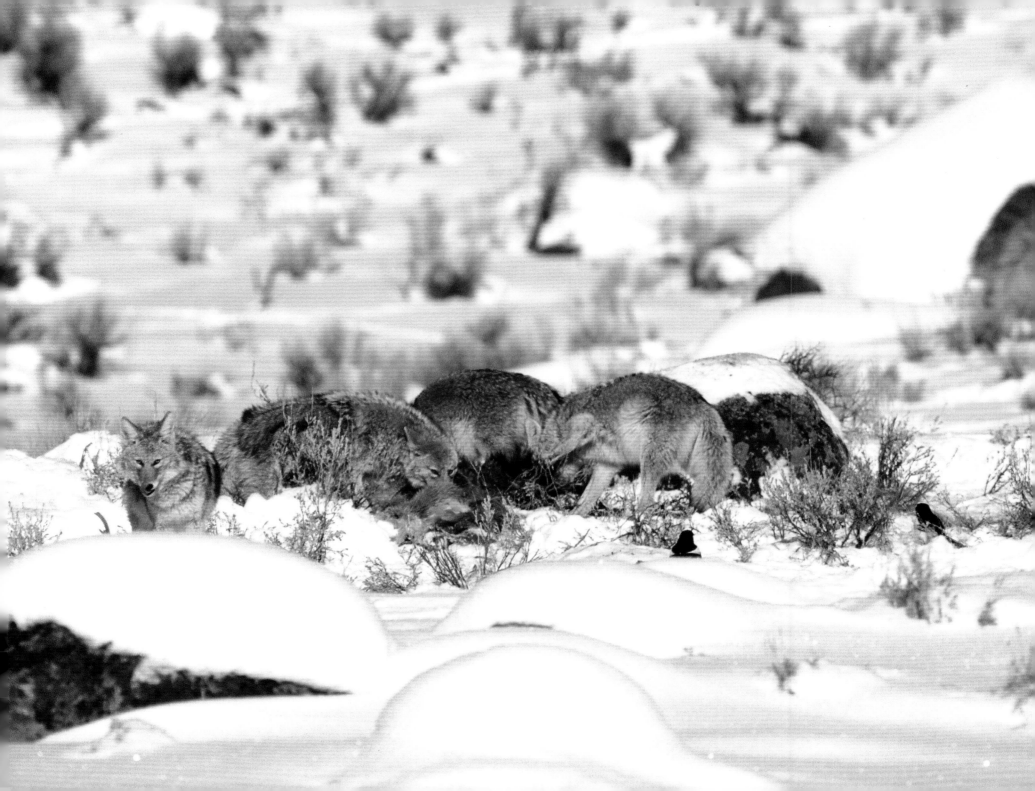

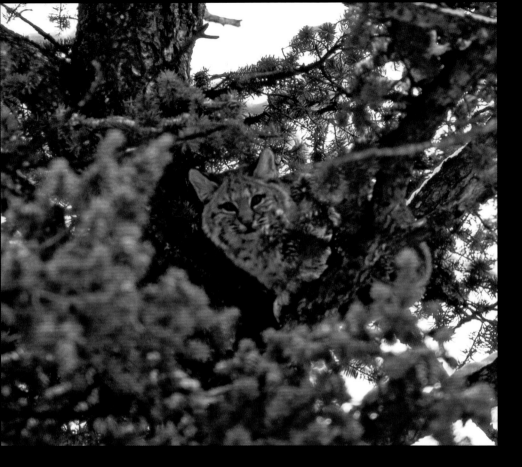

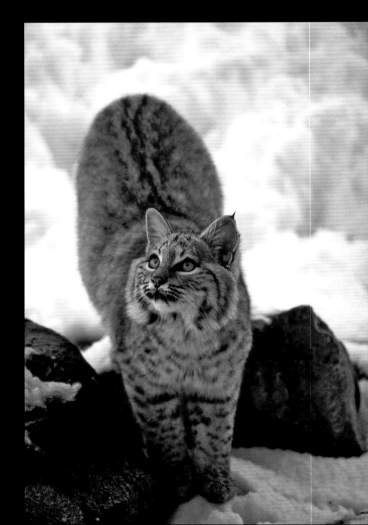

Because of their timid nature and nocturnal habits, it is very rare to see cats in the wild; however, sometimes it can happen.

The bobcat shown in the tree was tracked there by a friend with the help of his two dogs. After taking the photo, we left it, much to the disappointment of the dogs! The other bobcat shown was owned by a friend who previously managed a fur farm.

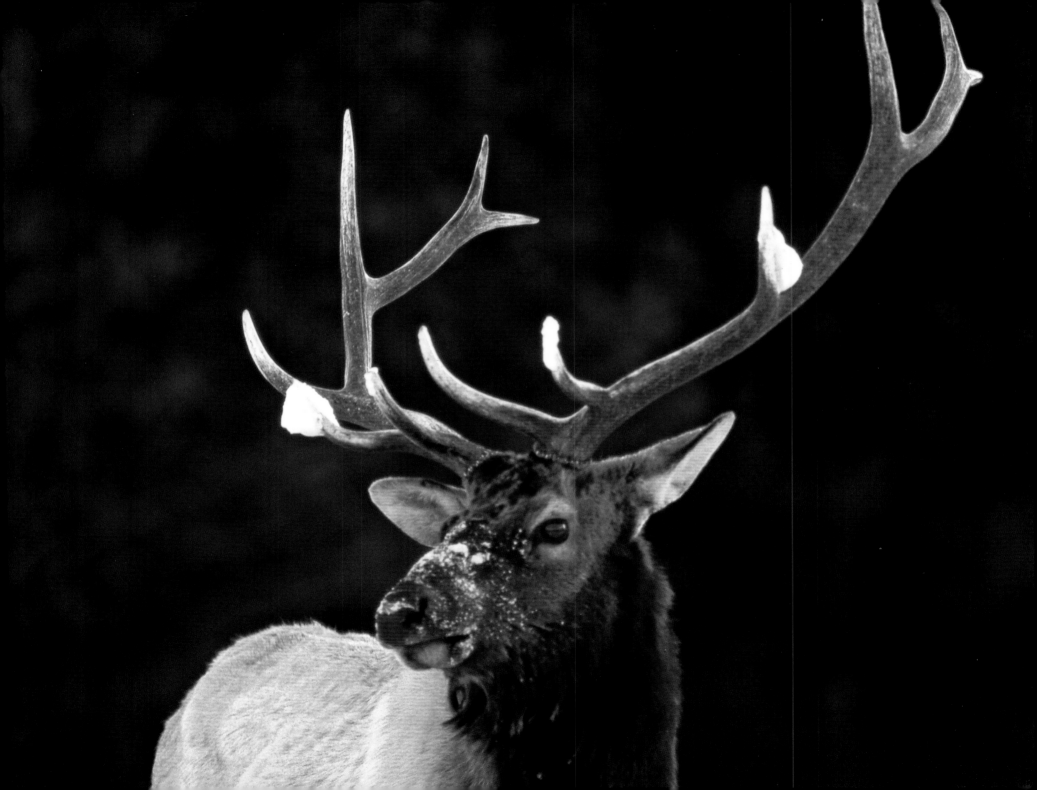

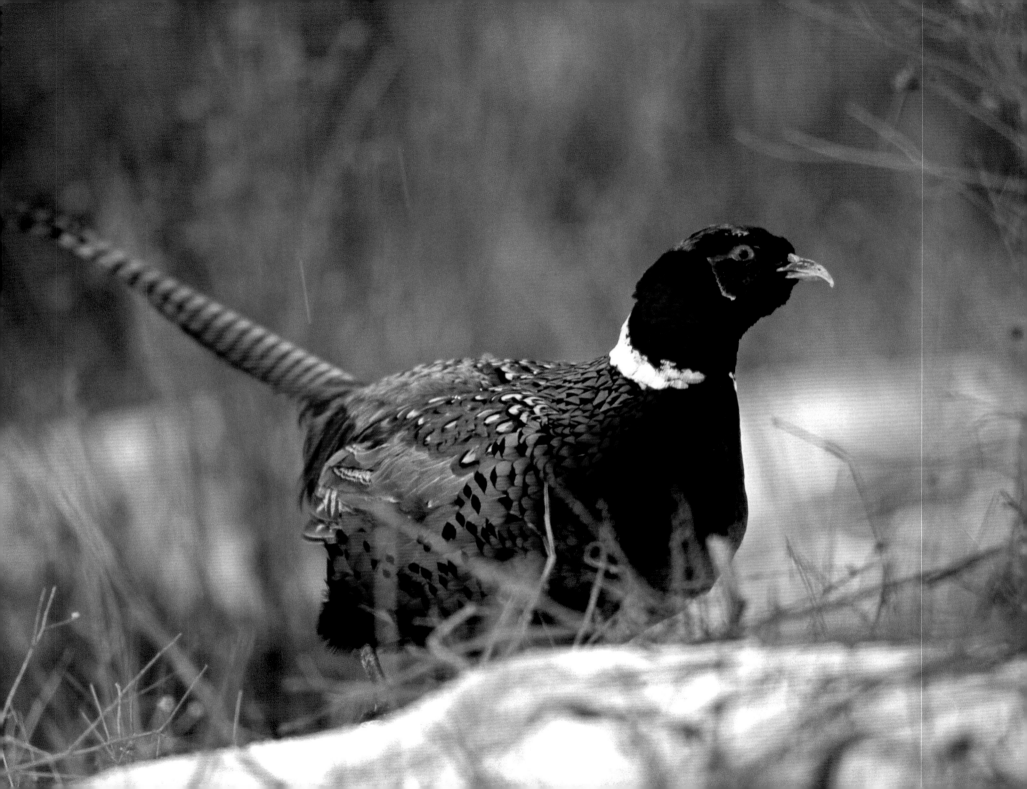

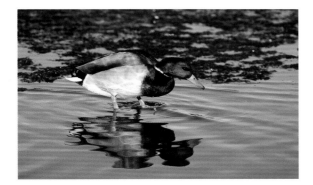

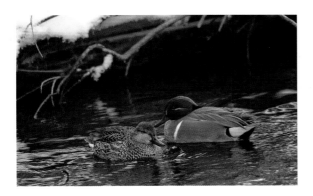

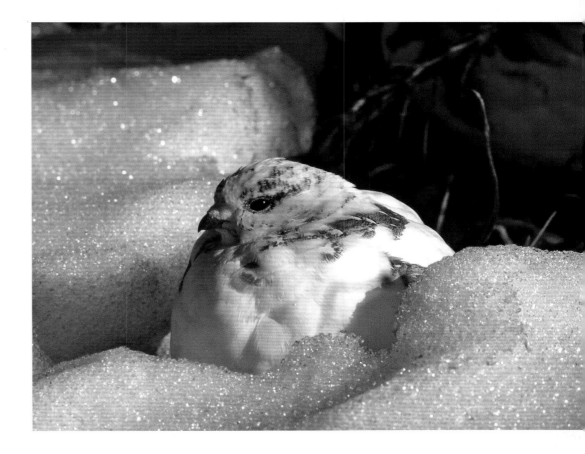

Another exception to winter inactivity is the habits of our upland birds and to a certain extent, many of our waterfowl. All of our upland birds are native to the area other than the ring- necked pheasant. I admire the way they can cope with some of our severe weather, and the pheasants have done a masterful job of adapting for being an import. A section in this book is devoted to upland birds, and there the ptarmigan was not included only because it is not classified as such because it is not hunted. It is, however, an upland game bird—very far "up" by living in high mountain ranges. The only place I have ever found any in Montana was high in the mountains of Glacier National Park. The ptarmigan certainly knows how to cope with winter.

Ducks and geese do migrate from this area during the winter season, but many also stay here for the entire winter. It is believed some of them have become "native" and stay for their entire lives.

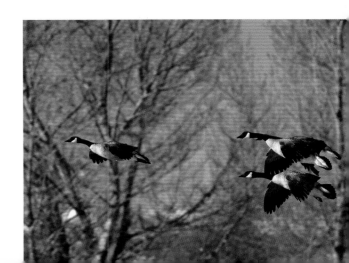

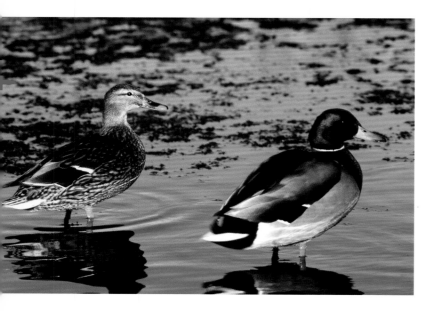

Although it can be very cold at times, I actually enjoy this season for taking pictures and to just experience the solitude and peaceful surroundings. Many times I have walked along a slow-moving, winding stream, water black against the snow piled on the banks, when it is absolutely silent other than the soft crunch of footsteps. Maybe a pair of mallards will splash out of the water vertically, the hen quacking in protest. Then again it is very silent.

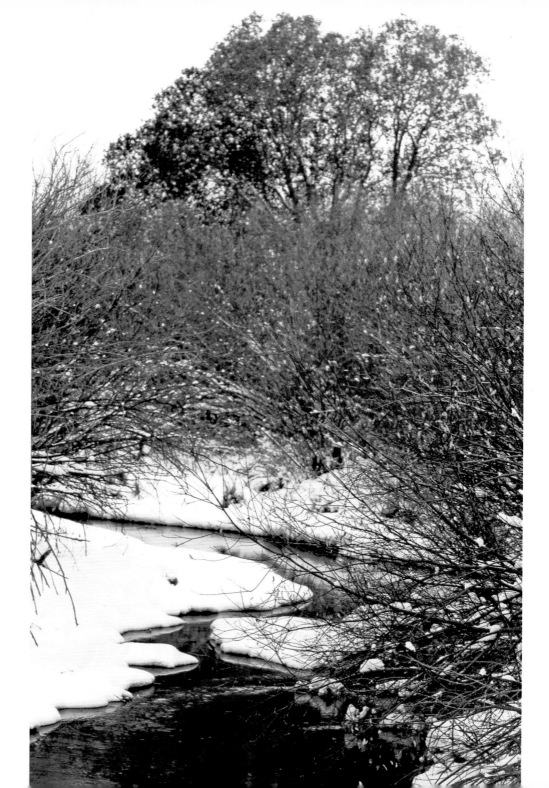

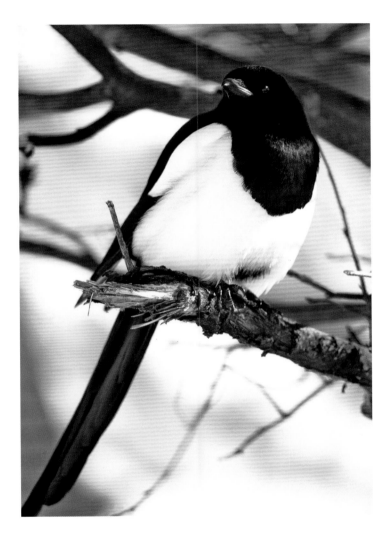

The magpie is noisy and sometimes quite obnoxious with its raucous call, but it is also beautiful with its almost formal black and white attire. It cleans up carrion and stays with us all year long. Not to take anything away from the meadowlark because it is a beautiful bird with a melodious song, but maybe the magpie should be our second state bird.

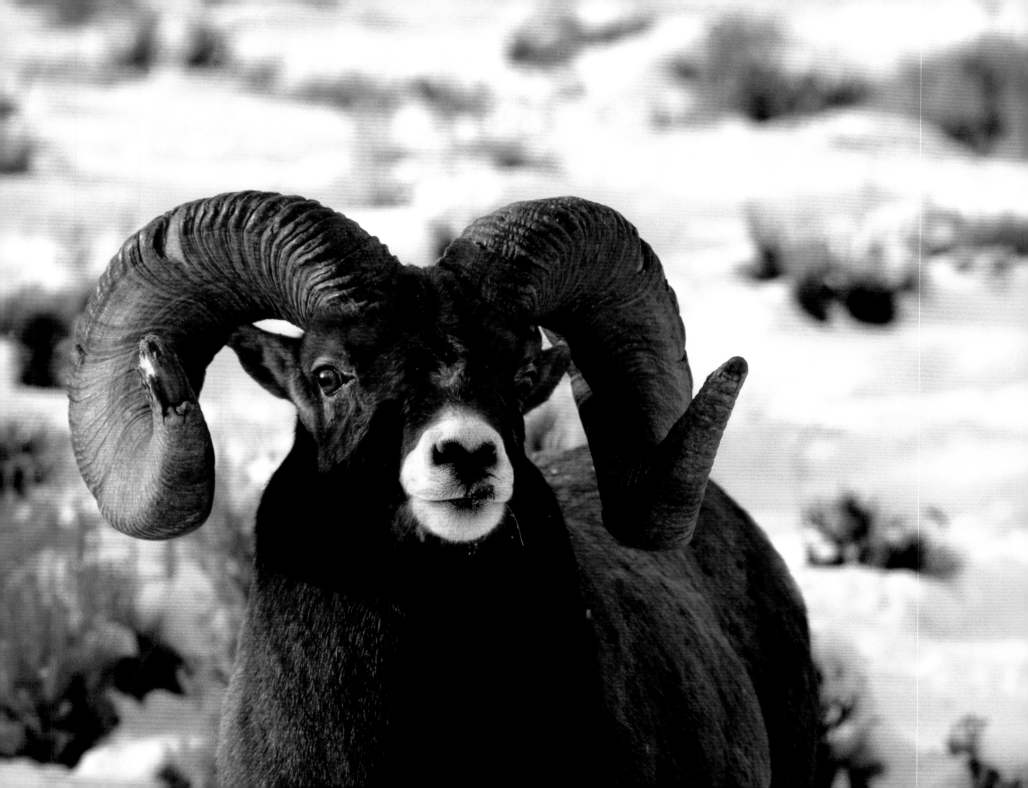

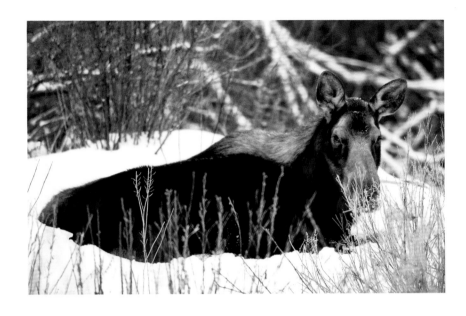

We are so very fortunate in this part of the country to have such a varied and abundant population of large wild animals. All of them are extremely attractive in their respective appearance and simply observing them is a pleasure, but to then record them on film is an extra treat. Fortunately, photography is an all-year activity and winter is no deterrent. Granted, it can be cold and fingers can become numb, but the results are very descriptive of how our wildlife functions during this portion of the year.

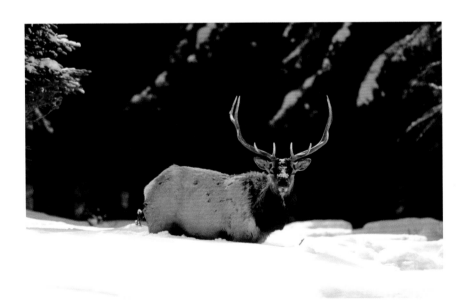

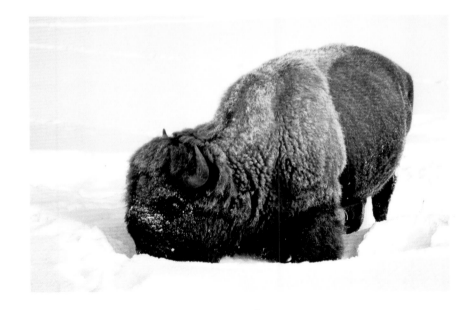

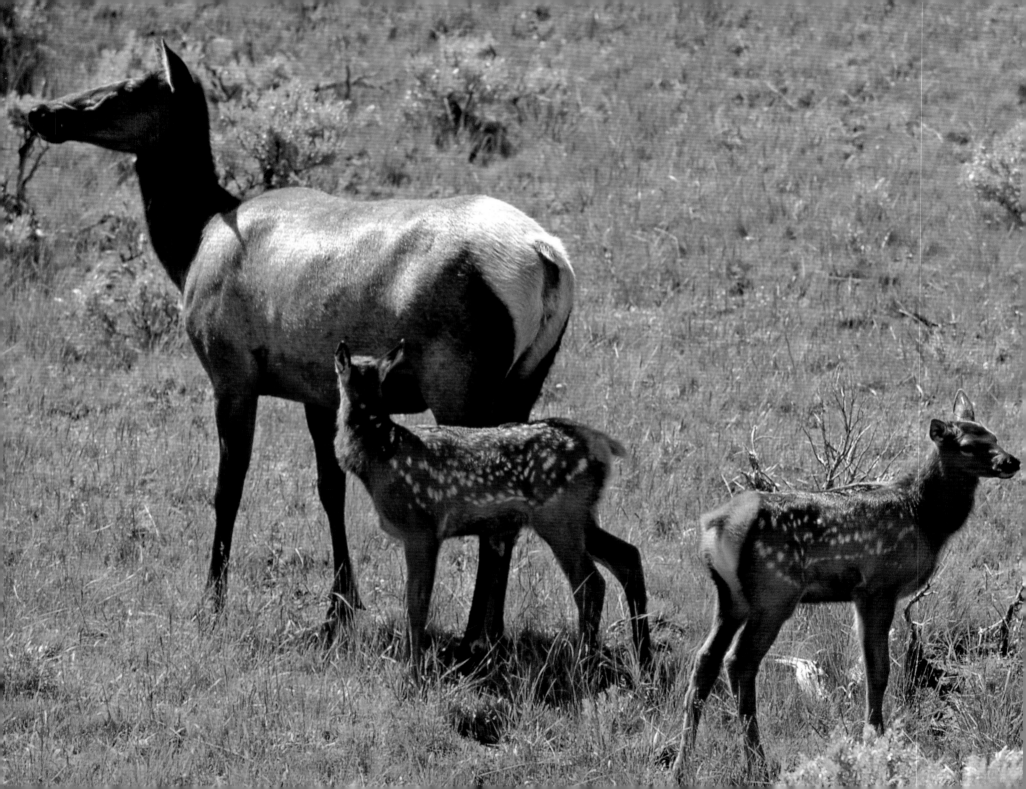

Spring

All things considered, this is a very busy season for all types of wild things in our part of the country.

THIS SEASON IS THE FIRST OF THE TWO most exciting times of the year when speaking of wildlife. Everything just seems to come alive, literally! Thousands of little animals are born, millions of tiny birds hatch and billions of plants and flowers sprout. What a wonderful time to be out where these things are happening and possibly record some of these miracles on film.

PROBABLY THE GREATEST THRILL and most exciting photographic work in the spring is finding and attempting to capture images of baby animals and their mothers on film. It is gratifying to see young animals, big and small, appear and know they will carry on to rejuvenate and multiply their species.

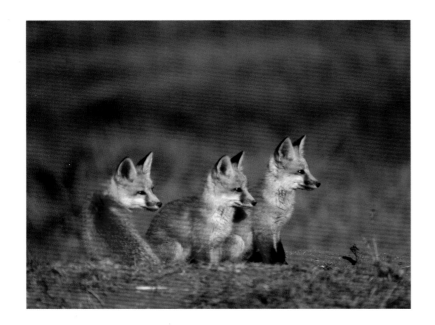

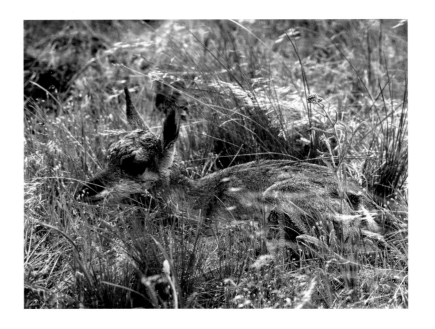

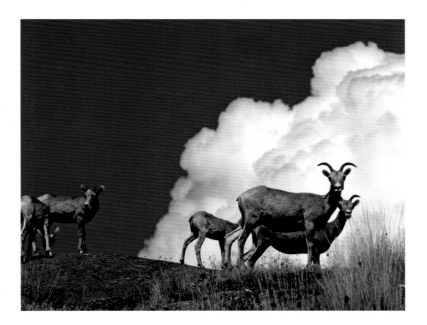

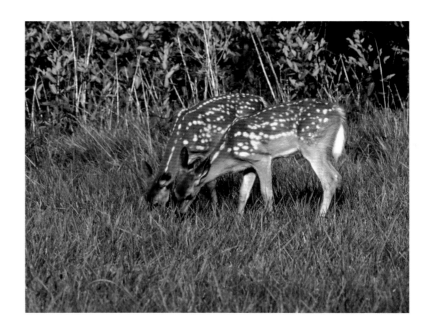

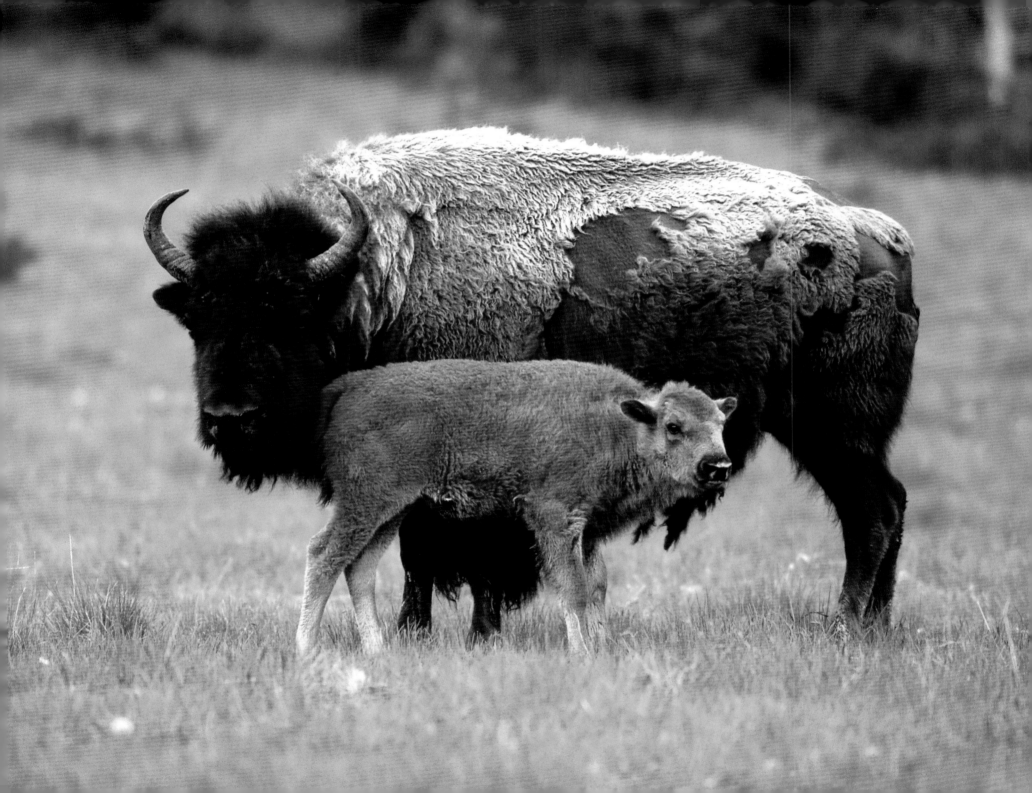

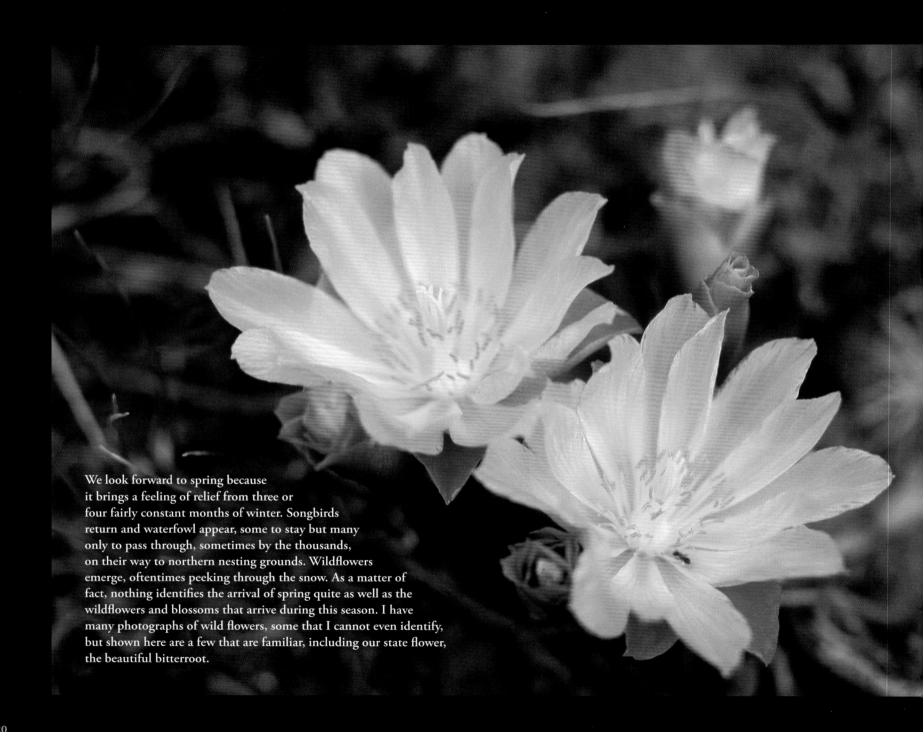

We look forward to spring because
it brings a feeling of relief from three or
four fairly constant months of winter. Songbirds
return and waterfowl appear, some to stay but many
only to pass through, sometimes by the thousands,
on their way to northern nesting grounds. Wildflowers
emerge, oftentimes peeking through the snow. As a matter of
fact, nothing identifies the arrival of spring quite as well as the
wildflowers and blossoms that arrive during this season. I have
many photographs of wild flowers, some that I cannot even identify,
but shown here are a few that are familiar, including our state flower,
the beautiful bitterroot.

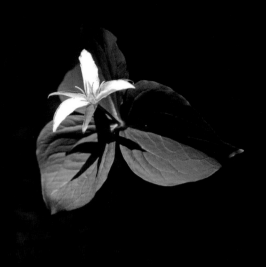

Trillium

Shooting Star

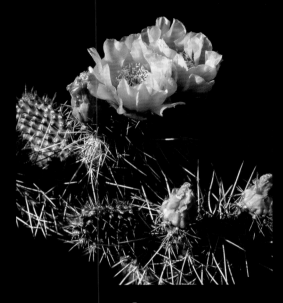

Cactus

Paintbrush

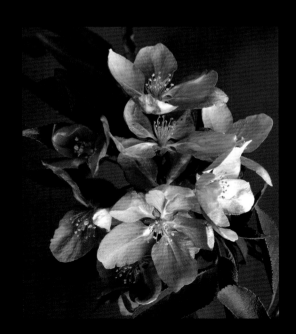

Apple Blossom

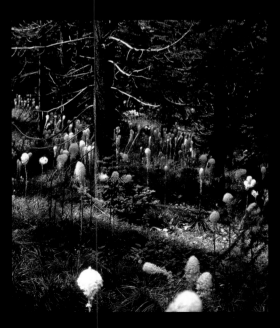

Bear Grass

21

For two consecutive years on Memorial Day weekend, my wife and I, along with our three ten- to fifteen-year-old sons, walked into the Sperry Glacier area to photograph baby goats. That was a strenuous one-day excursion because it was about fourteen miles round-trip. In addition, most of the trail was still snowbound in late May. All of that was worth the effort, however, because we got pictures of some very precious kids and their mothers. Our sons also had great fun glissading on the huge drifts. Suzanne and I made a third trip that turned out to be a bust. We first encountered a grizzly, which was a bit scary, and then saw a wolverine at a distance. But we failed to see a goat and felt those predators had scared them to a different location.

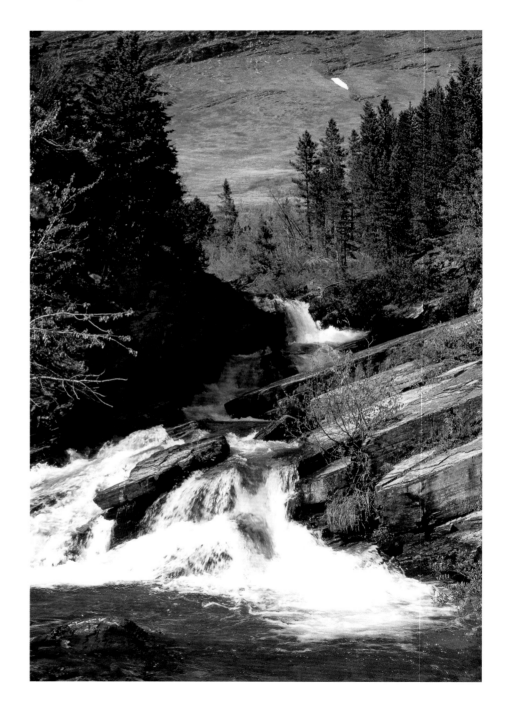

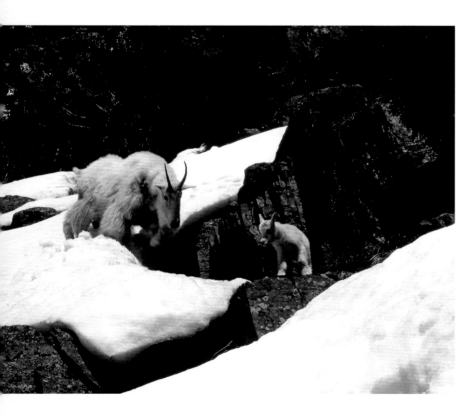

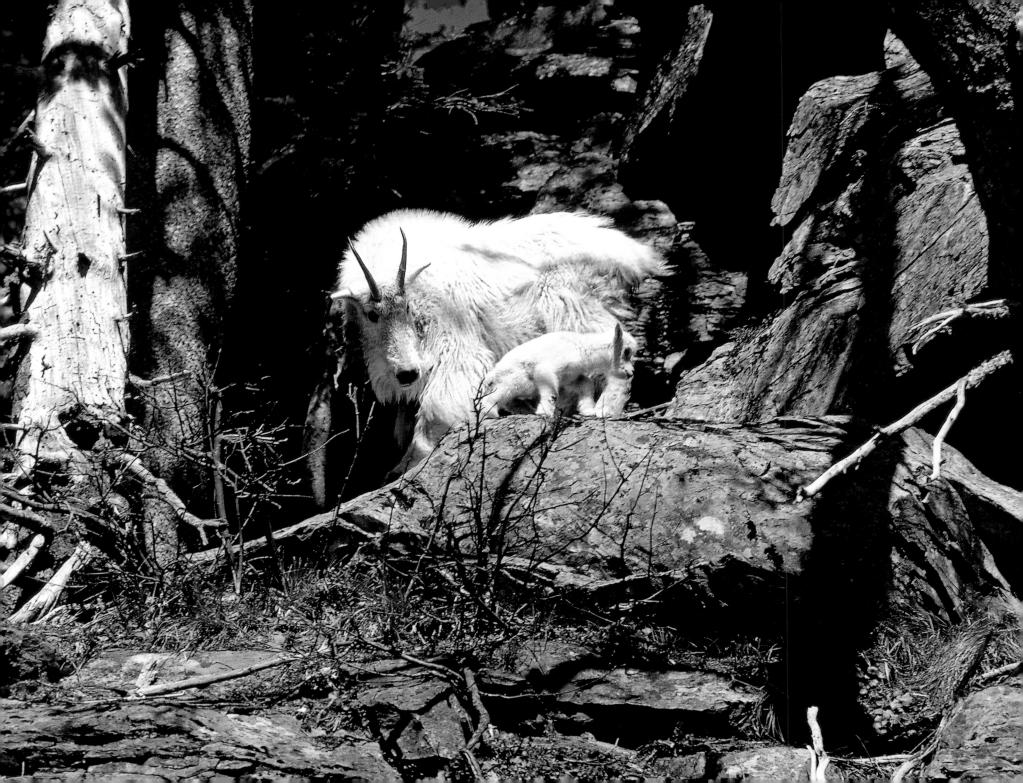

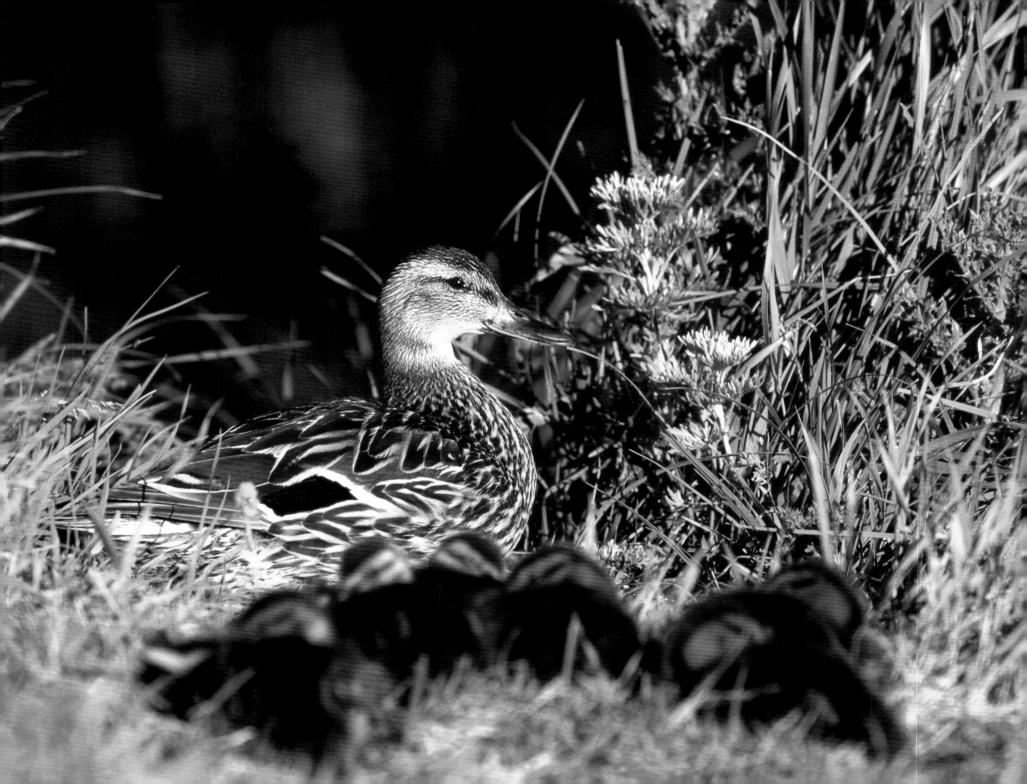

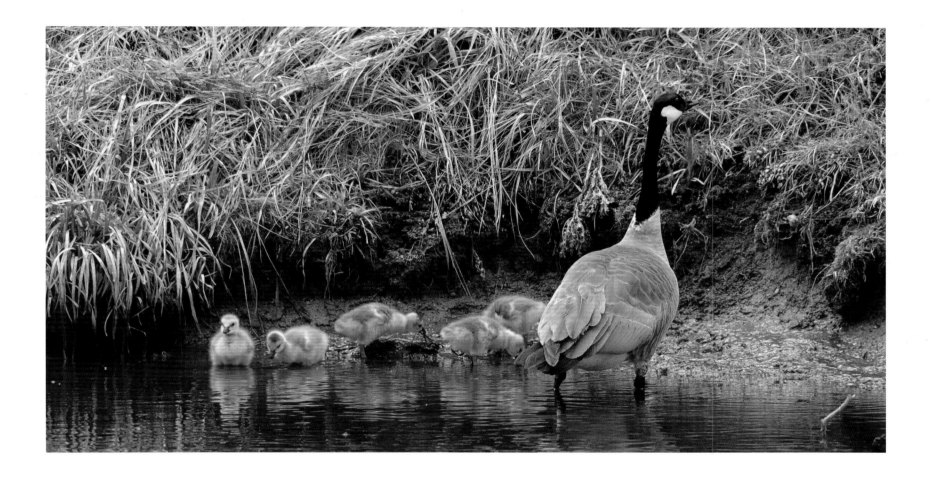

Ducks and geese are also a favored subject. Pictures of them are located throughout the book as they appear in the various seasons. Generally the males are the most attractive because of their plumage coloration, but both sexes have feathered patterns that are beautiful. Speaking of beauty, the wood duck just about has it all. We have some migration of these birds in the spring, but we have a limited population in this area. Even the Canada geese with their tuxedo-type appearance are pretty, regardless of the fact that their pictures could easily appear to be taken in black and white. Most of these birds are quite accessible but by no means all that easy to photograph. They are usually in perpetual motion, and even though they are amusing to watch, their antics can cause photographer frustration. One thing for sure, however, is that the babies of these birds, or waterfowl if preferred, are the cutest little things imaginable.

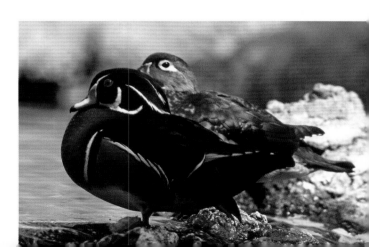

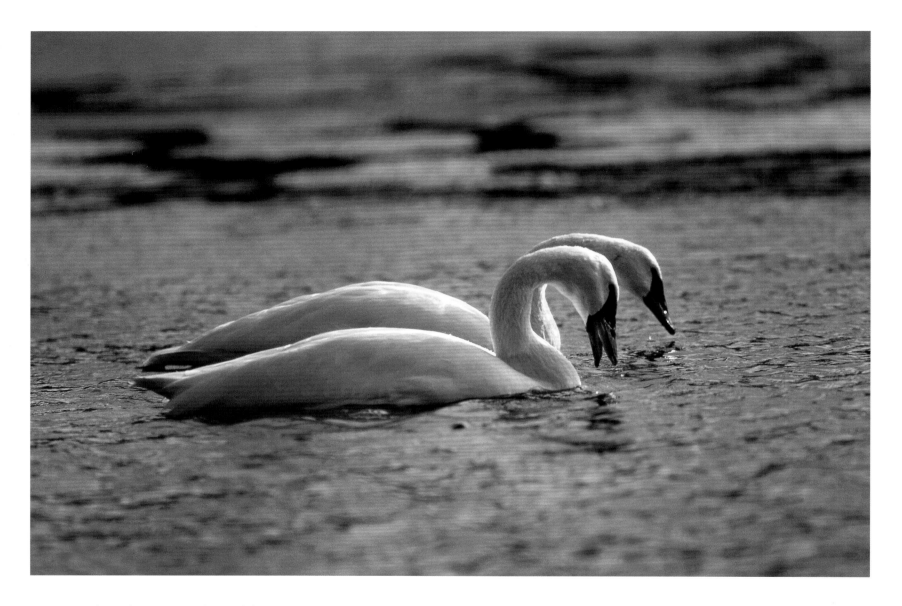

Freezeout Lake in the west-central part of the state is an extremely popular migration resting place. The photograph shown here was taken when tundra swans were passing through. Trumpeter swans were almost extinct sixty years ago, but with a great deal of loving care, good management and improved habitat, they have recovered quite well. From an estimated population of less than 2,000 in the early 1960s, they have increased to over 10,000 today. The picture of the handsome pair above was taken in the Red Rock Lakes National Wildlife Refuge in southwest Montana.

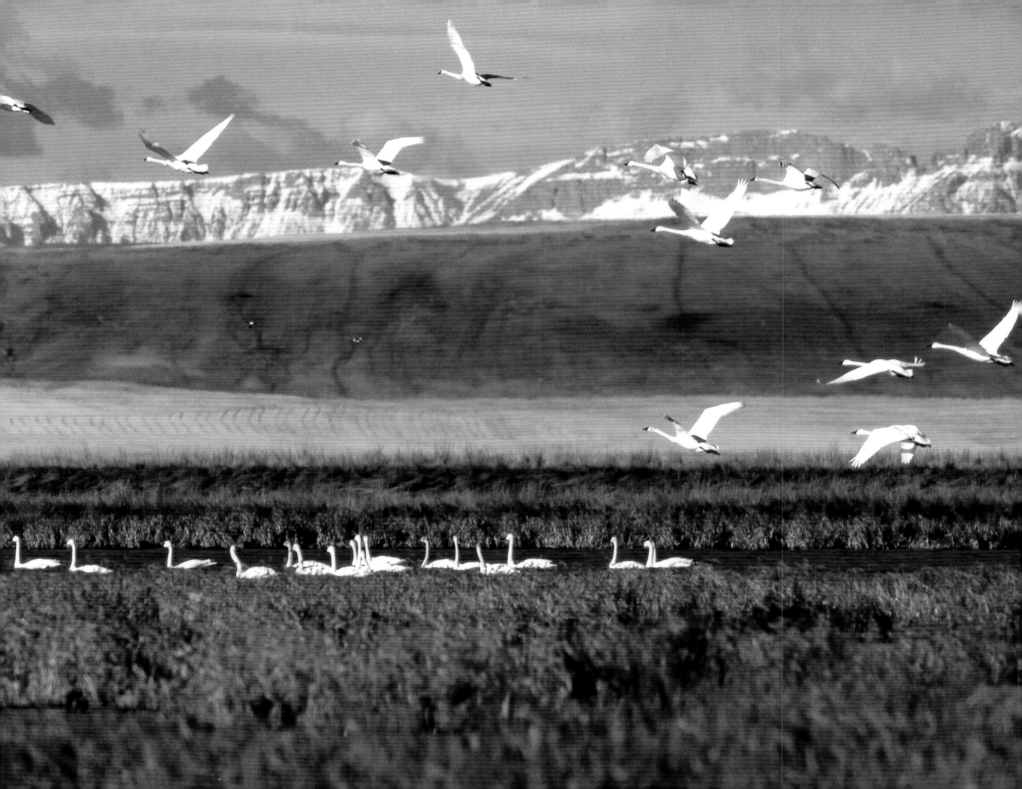

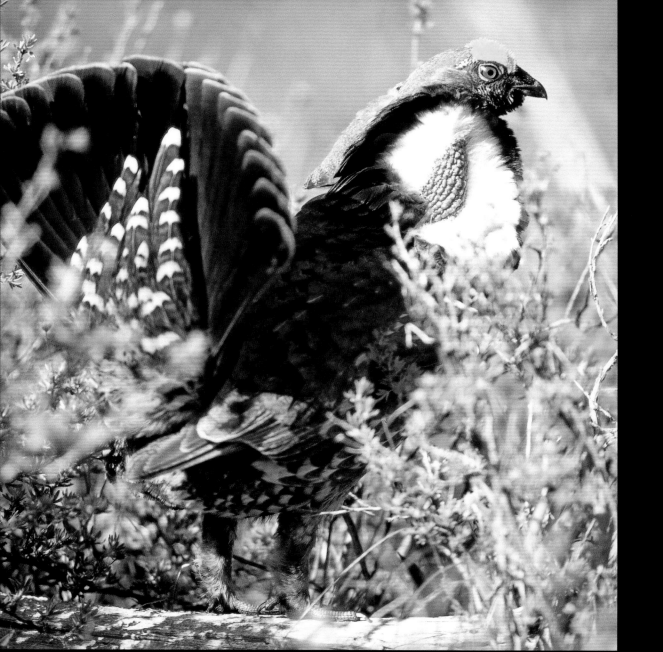

It has taken a great deal of time and patience to collect pictures of our upland birds in their mating attire. Most outings were very enjoyable, but getting up at 3:30 a.m. to be on a sage-grouse lek at daylight was a bit of a stretch. If it is clear, however, the rising sun on the birds is dazzling. One problem, though, is very shortly after the sun rays reach the ground, the male birds disperse.

Although I have tried hard to capture on film a ruffed grouse drumming (wing beating on its body), it has not happened. This one was on the log a good long time while I was patiently waiting, but he was not about to accommodate me! I did notice his mate on her nest while she was turning her eggs.

All of these birds are so beautiful and a pleasure to see. I just wish there were more of them.

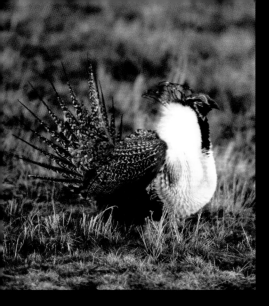

Sage-Grouse

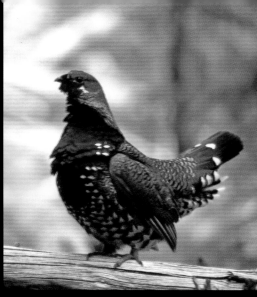

Franklin's Grouse

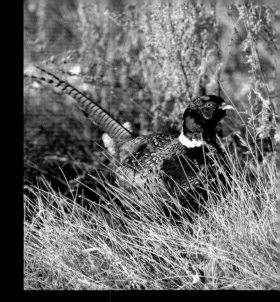

Ring-necked Pheasant

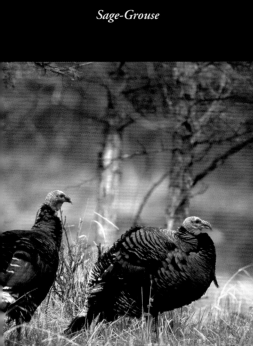

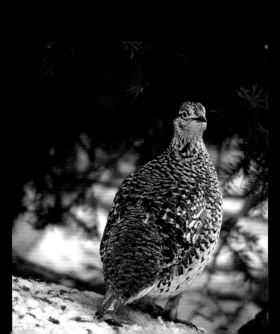

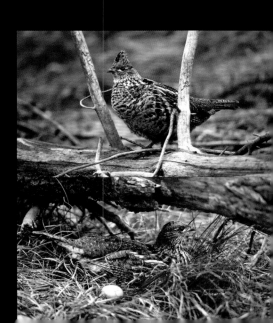

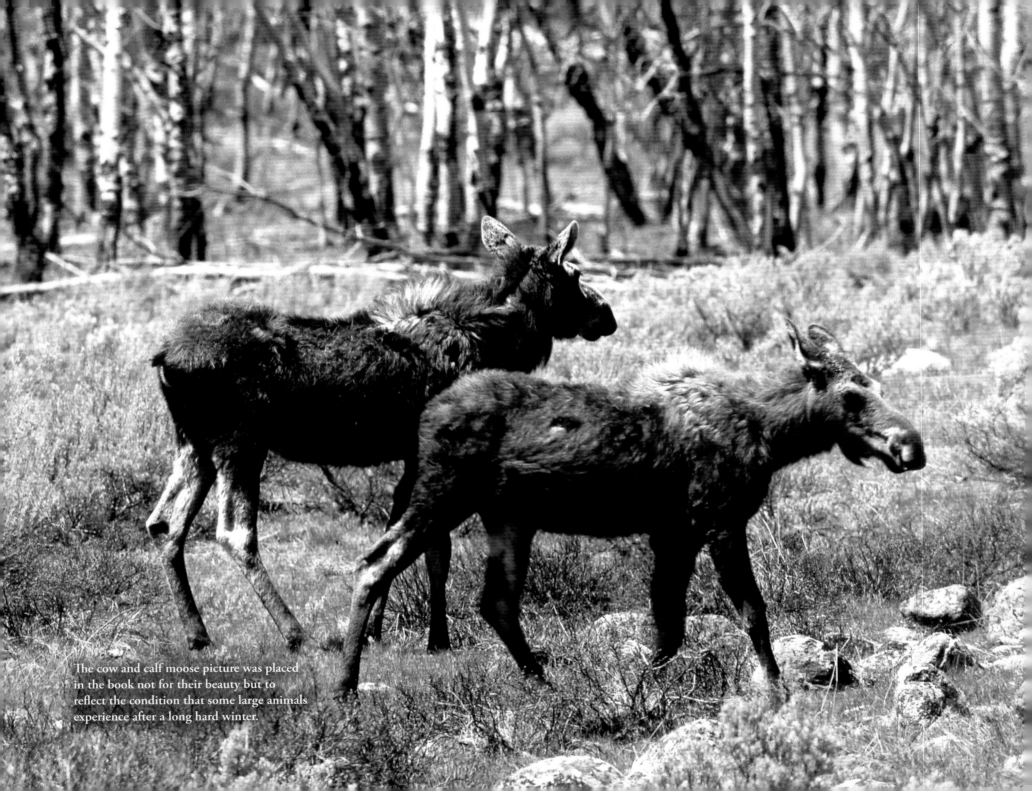

The cow and calf moose picture was placed in the book not for their beauty but to reflect the condition that some large animals experience after a long hard winter.

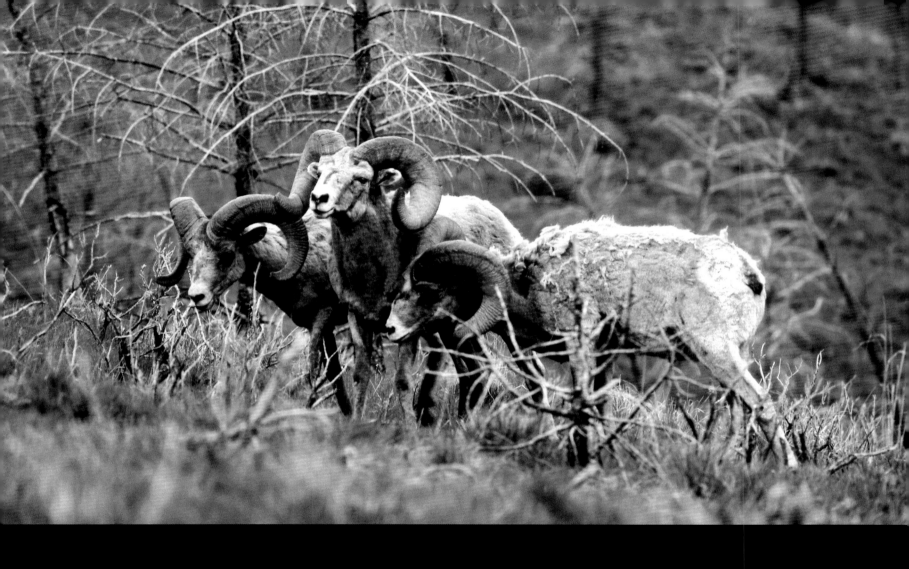

The three bighorn rams pictured also are in very poor condition in early spring. But this photo has a story. The ram in the middle is a very large specimen. This picture was taken in the Cattle Gulch area near Melrose, Montana. Later that year in midsummer, Jack Atcheson Jr. of taxidermy fame and Mike Fresena, a biologist for Fish, Wildlife & Parks, found a dead sheep and recovered the horns. After scoring the head they discovered the measurement to be a new Montana record. After showing them this picture, they were of the opinion it was the same animal.

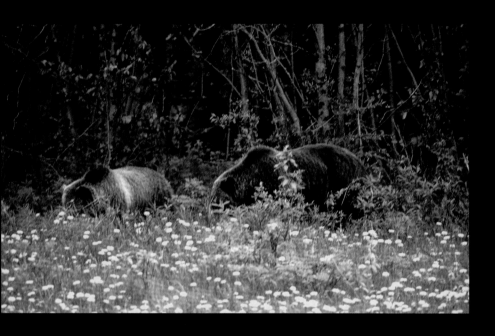

The two handsome grizzlies in the dandelions were mating. The photograph was taken in May, and with a nine-month gestation period, she would give birth in her den in February.

The bears and wolf is not a great picture but has an interesting if somewhat sad story. At a considerable distance with glasses, I spotted three wolves harassing a cow elk and her very tiny calf. Hurrying as rapidly as I could to get closer, I noticed they had killed the calf and the cow was running away. By the time I got as near as I thought I should, a sow grizzly and her two-year-old cub had arrived and immediately took over—they are very dominant. By the time I was in position to shoot pictures, two of the wolves had left. Still, a picture of grizzlies and a wolf in one frame is quite interesting.

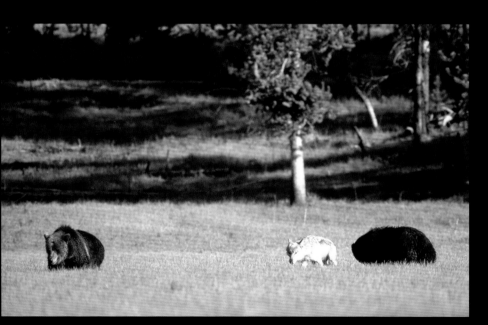

Taken a mere twenty miles from my home in Butte, this photograph of the Fleecer Mountain area portrays spring in all its glory.

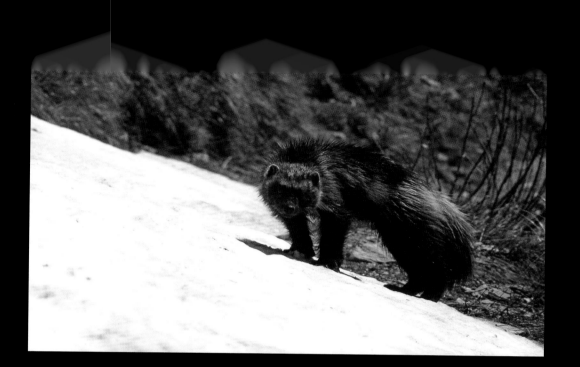

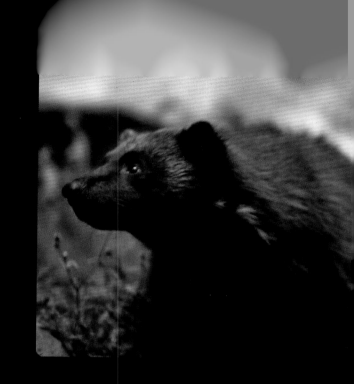

Very similar to the cat families, it is also extremely rare to see a photo of a wild wolverine. This picture of one gives me a treasured thrill. At about ten o'clock one spring morning I was coming down a mountain north of Swiftcurrent in Glacier after having taken pictures of goats. Fortunately the camera was mounted on the tripod when I reached the trail leading back to camp. Suddenly, coming up the mountain below me was something making a sound somewhat between a wheeze and a growl as if it were talking to itself. Kneeling behind the camera, I waited a short time and up popped this wolverine thirty yards in front of me. He detected me very quickly and it was a fast opportunity, but I was able to get a couple of shots.

The other photo is of a wolverine in an enclosure, but it is a good close-up to observe what these animals look like.

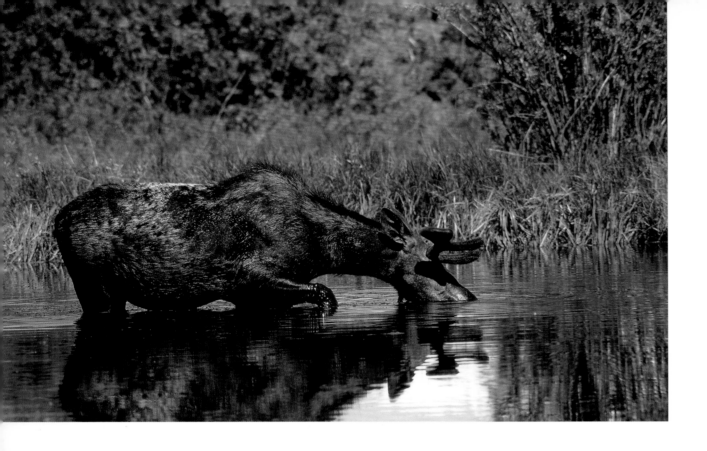

The moose and elk pictures shown here make me feel that spring is in the air. It is also a good feeling that they are comfortable and feeling well themselves.

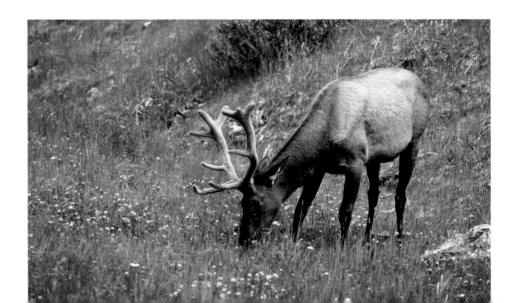

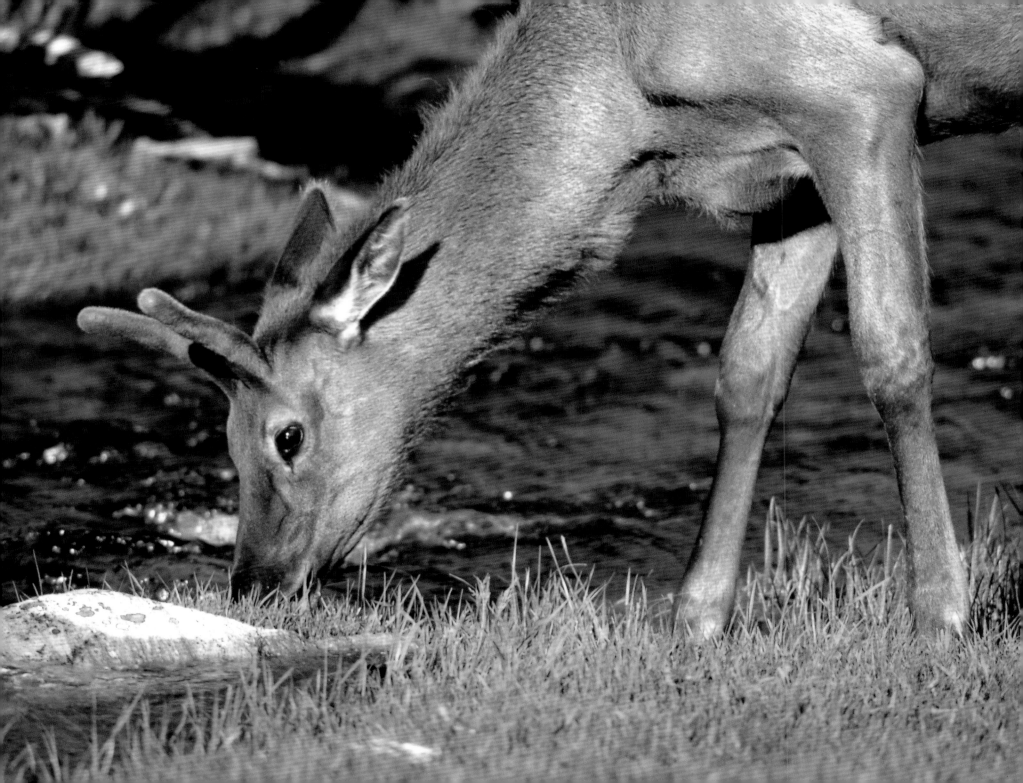

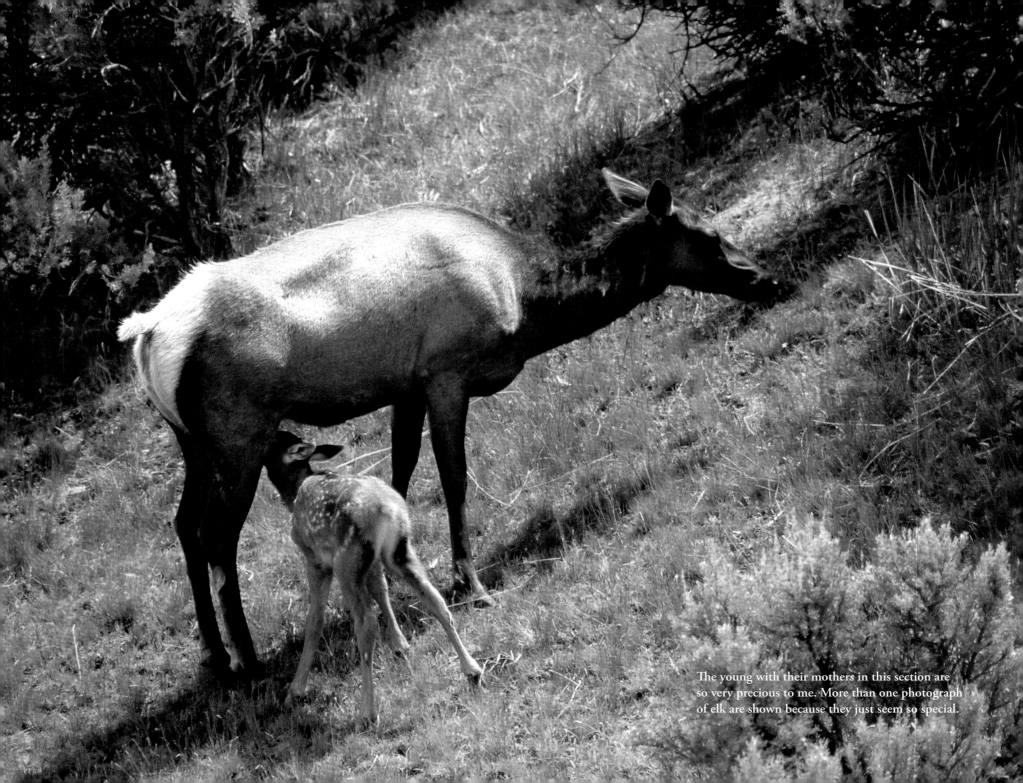

The young with their mothers in this section are
so very precious to me. More than one photograph
of elk are shown because they just seem so special.

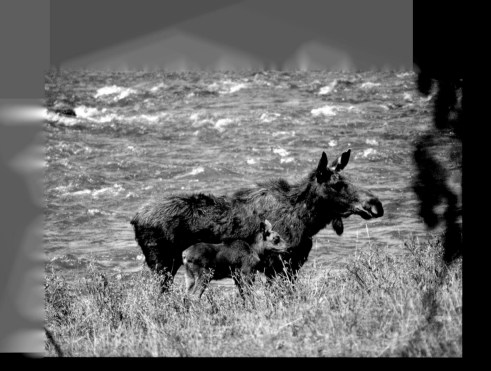

Little pups and kittens and all other domestic animals are very cute. But here in our surroundings, with some patience and work, we can observe other very wonderful babies. I am confident no one can help but loving the new born wildlife.

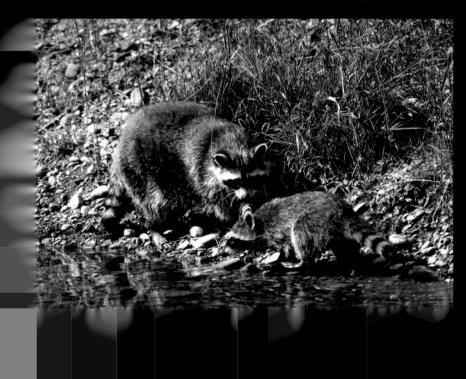
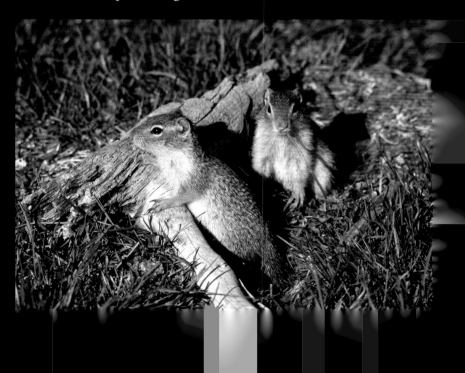

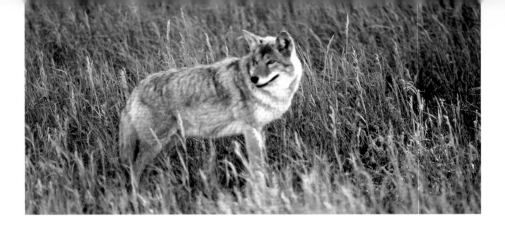

Relative to this ecstatic time of rebirth, however, is a phenomenon with a somewhat sad note. As perfect as Mother Nature's plan may be, it is difficult to accept the fact that some animals survive by taking the life of others. The wildlife shown, whether they be mammal, bird, insect or reptile, are predators. There is a story about animal predation that is worthy of comment as it fits into our current wildlife picture.

For thousands of years, animals living on the North American continent existed in a remarkably balanced state. Native Americans, with some slight impact, blended into the scheme of things well, but with the arrival of Europeans, the greatest predator of all, the balance of predator and prey rapidly became skewed.

Because four-legged predators competed for the same prey, a battle for dominance began, and by the early 20th century it was clear who was winning.

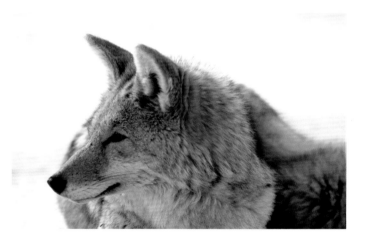

There were many predators, but those most identified to be eradicated were the grizzly, wolf, mountain lion and coyote, and by the 1930s humans had done a very thorough job.

Fortunately, in the 1950s and gaining momentum in the next two decades, we realized that these animals are important too. In fact, it is helpful to have them assist in controlling the increase of ungulates, especially in parks and other places where hunting is not allowed.

Once again we have a fairly balanced population of predators and prey through good management. There is concern about the controversial subject of wolf numbers, which will not be discussed here.

Each of the species received protection until their numbers increased to the point of requiring management, supervised by game managers and executed by hunters. The one exception is the coyote, who is still classified as "predator" and may be killed at any time. Fortunately, in my opinion, he has been protected some by the banning of poison. This canine has had many setbacks, but he still thrives. Some old-timers who have pursued them over a long period of time have made the prediction that a coyote will be sitting on the grave of the last human on earth—and they may be right!

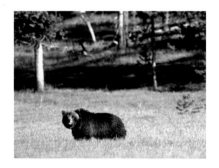 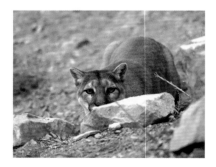

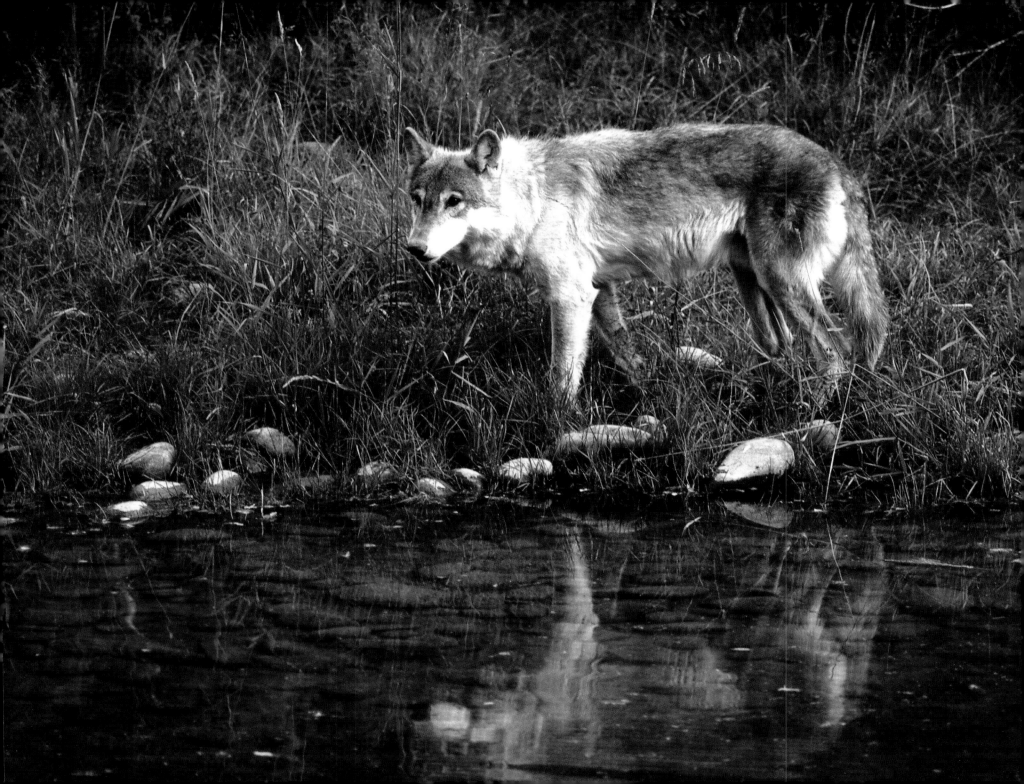

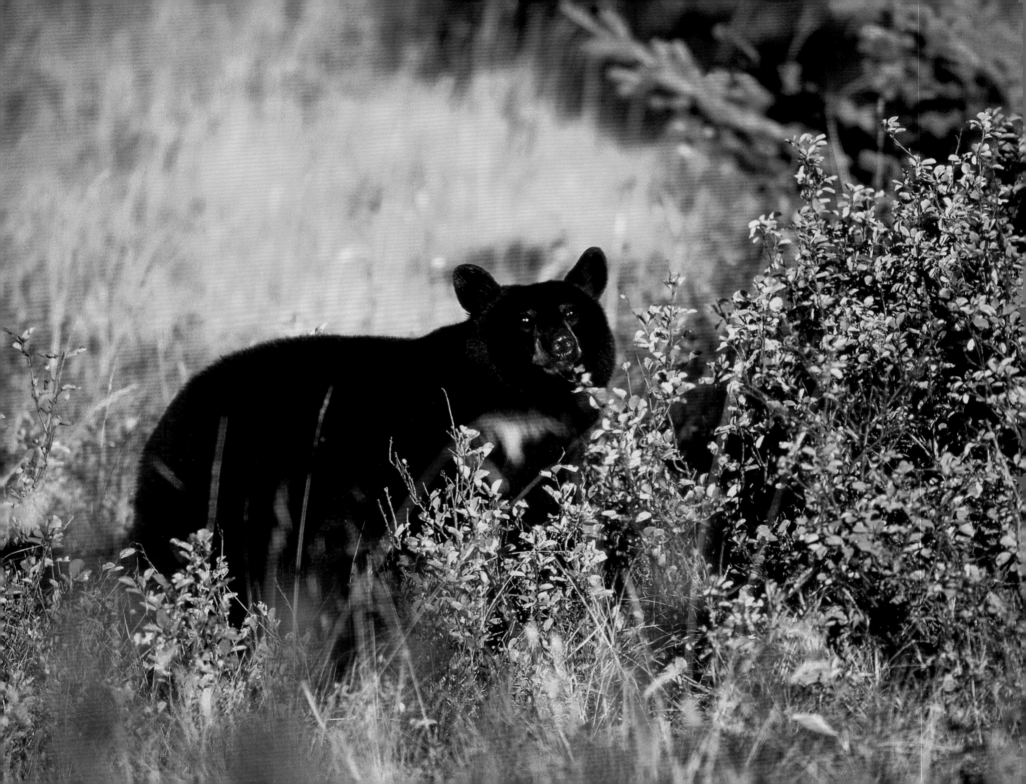

Summer

Cold streams are finding their way down the mountainsides, and fresh new flowers are still blooming along springs.

THIS IS THE TIME FOR ANIMALS and birds to recoup, to be comfortable and to recondition. It is the time to nourish the young and start them on their way to becoming strong and healthy enough to sustain themselves in the coming, more taxing seasons.

IT IS ALSO A LAZY PERIOD WHEN ANIMALS are often observed lying, stretching or stoking up on food. All populations are gaining weight and appear beautiful, somewhat in preparation for the upcoming breeding season in the fall months. Bison are an exception—because they have a ten-month gestation period, they breed in August so their birthing period will arrive in early spring.

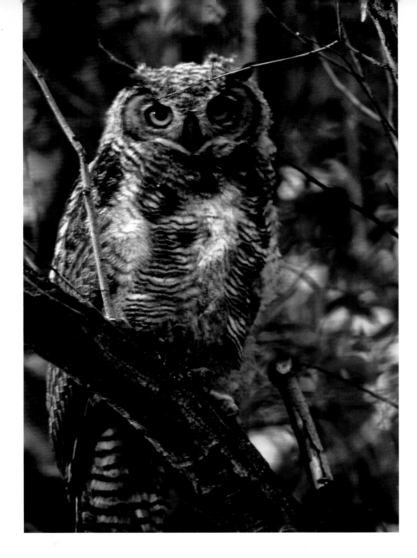

The great horned owl is an interesting subject. They start nesting in February, which is the earliest of any bird that I know. Consequently, their offspring are almost grown by late June.

There are extremely few lynx in the Montana/Yellowstone area. The greatest reason is because of the demise of the snowshoe hare. Shown is a picture of one of those rabbits in its winter attire that was taken long ago. I have observed very few of those animals since then, but I am glad to report that lynx have thriving populations in northern Canada and Alaska. The photograph of this one was taken in a managed area.

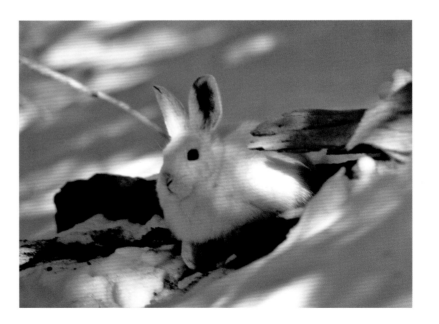

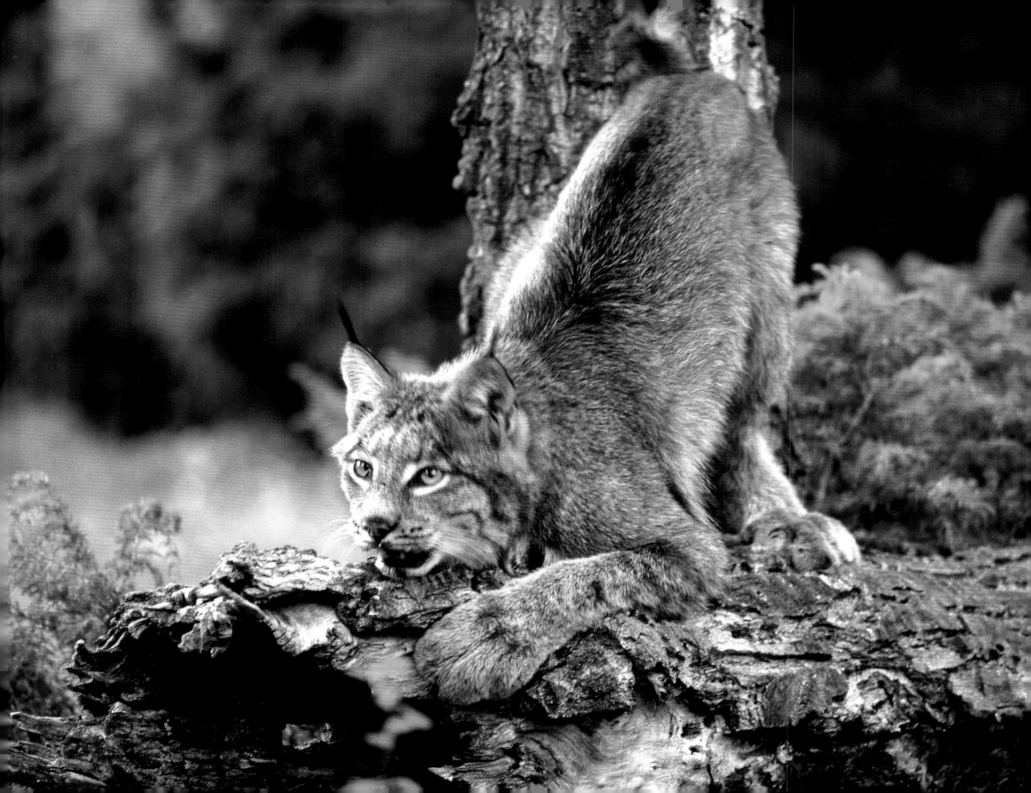

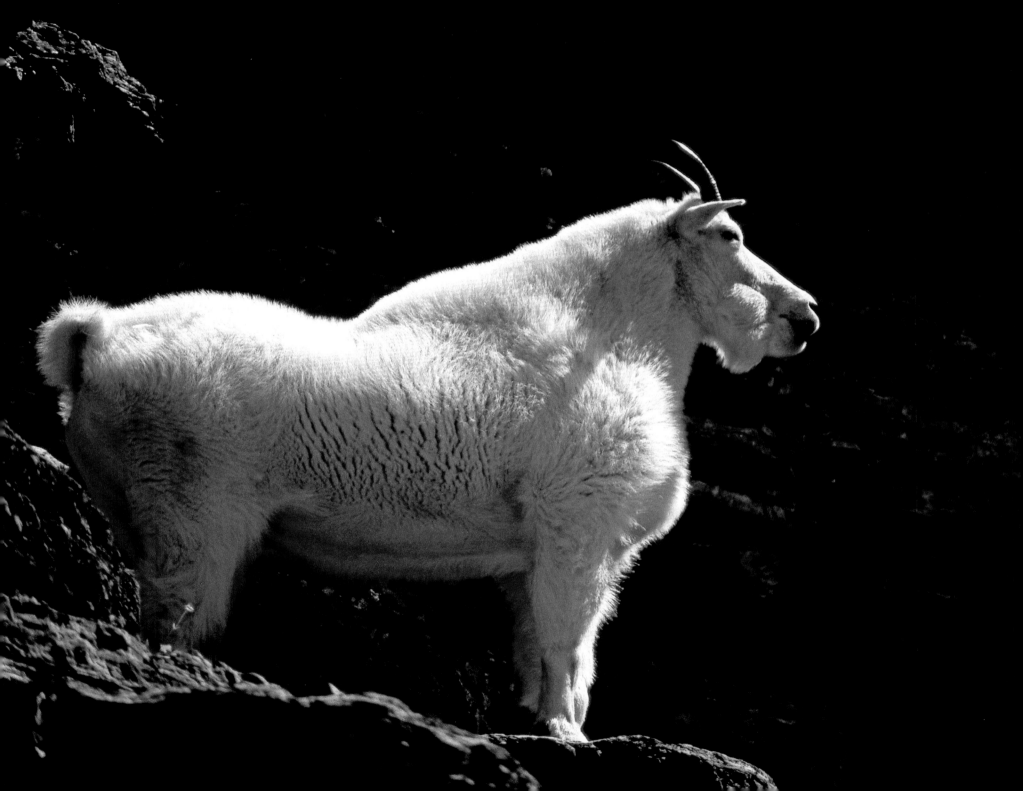

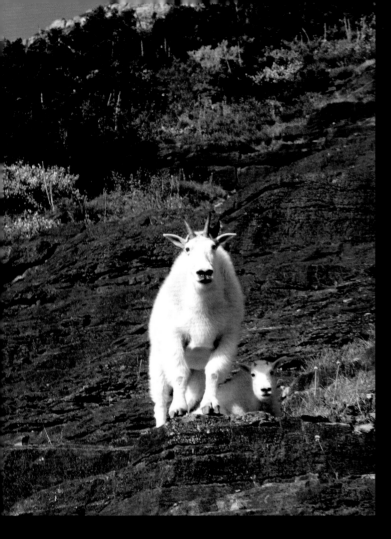

Many hours spent with mountain goats have left an impression with me of their being stately and majestic. They exude a sense of tranquility, and time spent with them is time spent in peace.

The sandhill crane photo was a pleasant surprise. They are a tall, structured bird with good eyesight and it is not easy to get close to them. On this occasion, I was in a makeshift blind waiting for whitetail deer when a pair of cranes flew in almost on top of me. They discovered me almost immediately, but this shot turned out remarkably well.

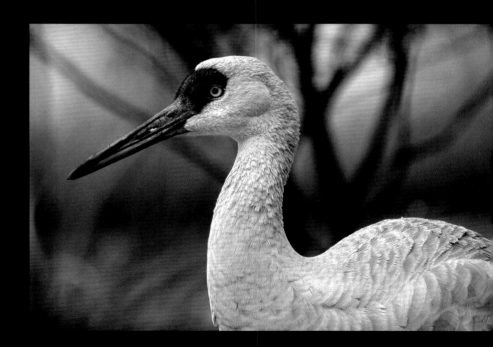

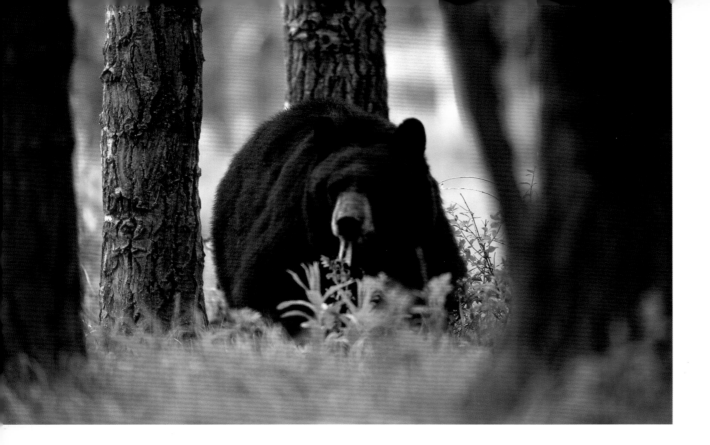

Bears are fascinating and challenging photographic subjects. Despite their sometimes comical behavior, it is difficult to get close enough for a good photograph due to the serious dangers these wild creatures pose. Great care must be taken—for the animals' safety and your own. This is especially true when sows are caring for their young. It is a very good idea to have some knowledge of their body language when in their presence.

Regarding the young, note the three cubs in the far right photograph. It is a fairly known fact that this species is called "black bear," but their fur can also be black, brown, cinnamon or even white—sometimes in the same litter. Today, up to 950,000 of these well known wild bears inhabit Alaska, Canada, the United States and Mexico.

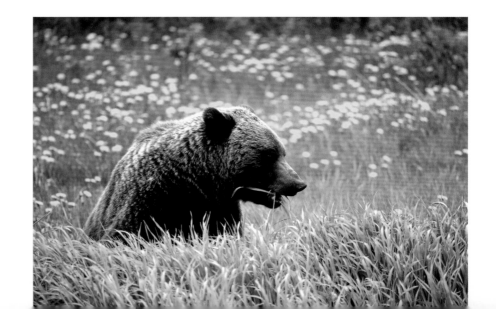

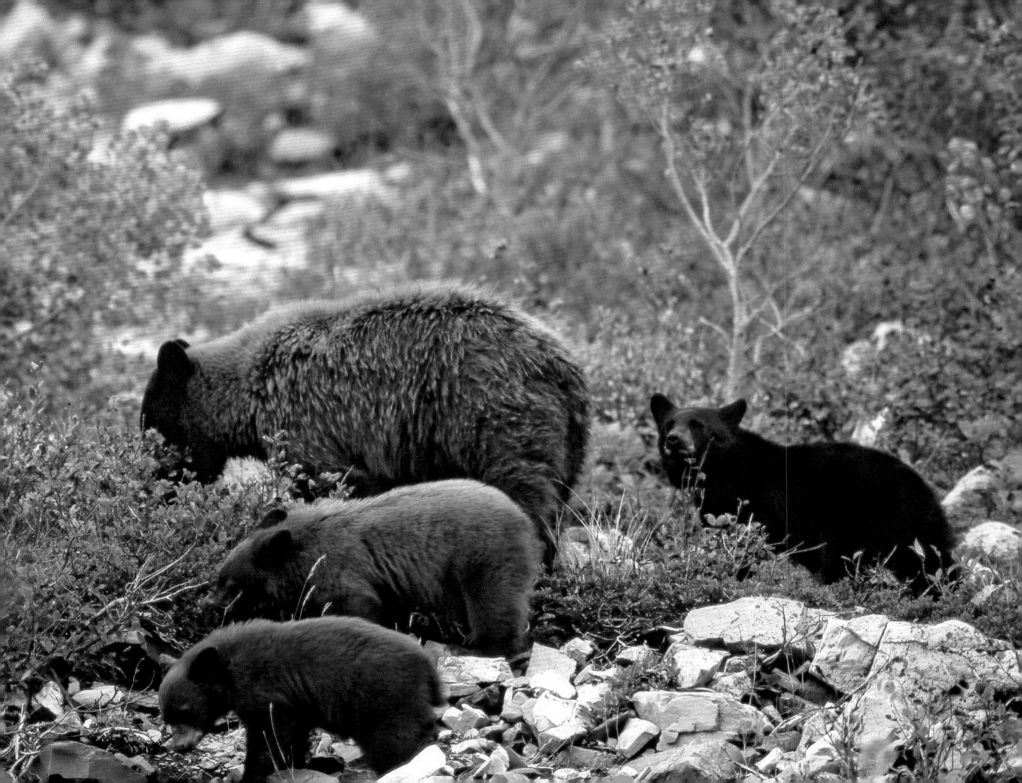

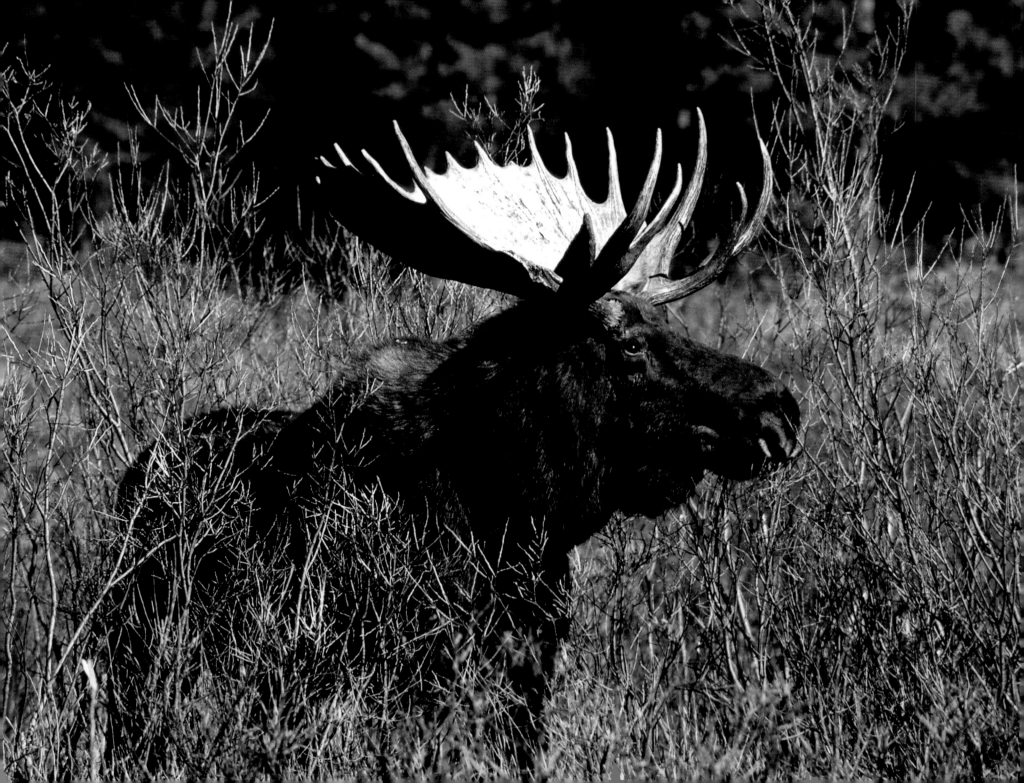

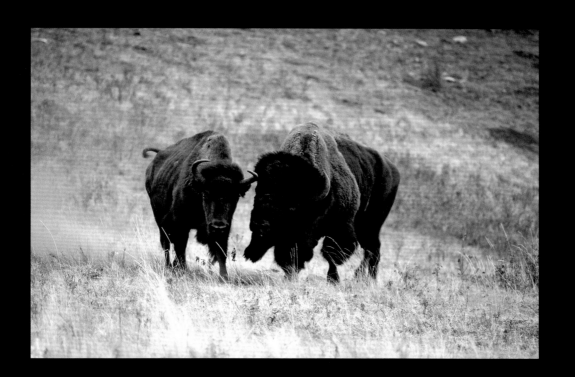

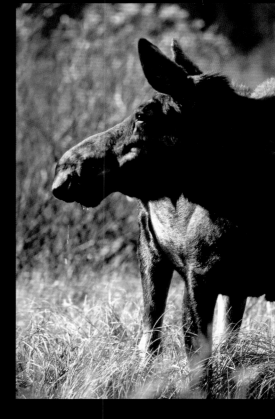

Speaking of body language, it is important to know the
warning behaviors of all animals. When a cow elk grinds
her teeth, a cow moose lays back her ears and especially
when a buffalo stands abruptly, stands stiff legged or
emits a guttural sound—get out of there, you're too close!

Bull moose can also be dangerous even when they are not
trying to be. Something startled this one and he came
crashing out of the willows straight my way. I threw
myself out of his line of flight as far as I could and was
lying on the ground when he went past. I doubt that he
even knew I was there!

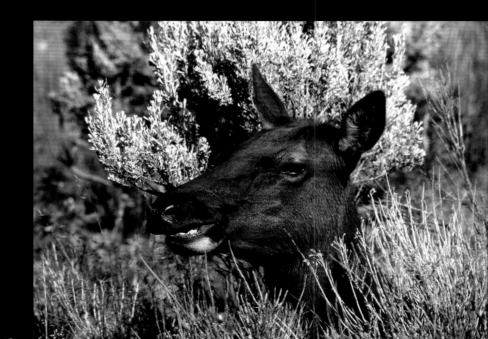

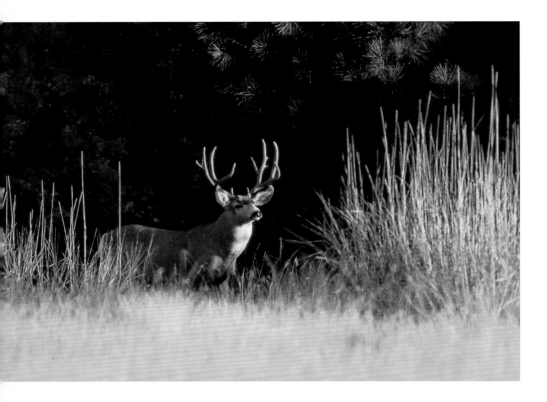

If I were to measure the time spent with any given species, I would have to give the record to elk, and deer would come in second. If a rating of love would also be considered, deer would come in first. They possess the characteristics that simply attract. They are timid, statuesque, sleek and just about any other favorable adjective that describes something living. After a session of satisfactory deer photography, I'm left with a feeling of happiness, contentment and admiration.

The picture of the seven buck deer posing is one of my top favorites. I doubt if their placement could be improved a great deal if they were taken into a studio and arranged for their portrait!

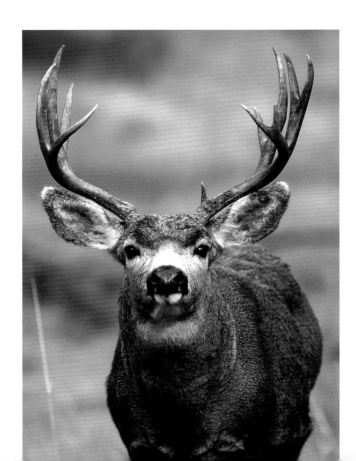

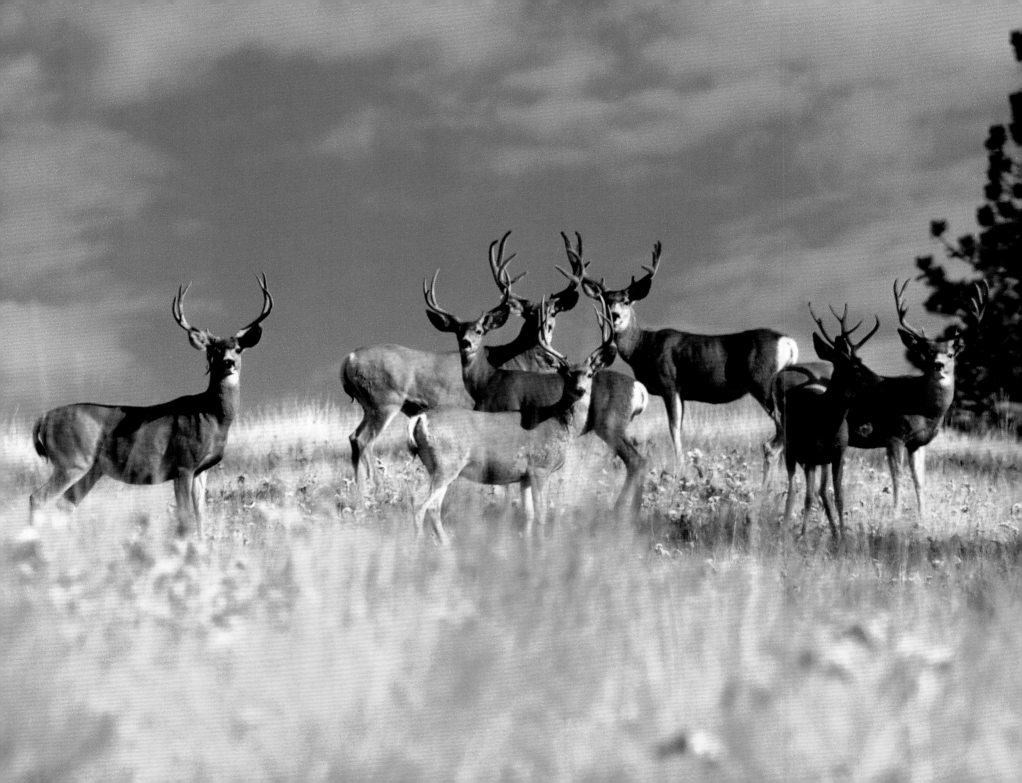

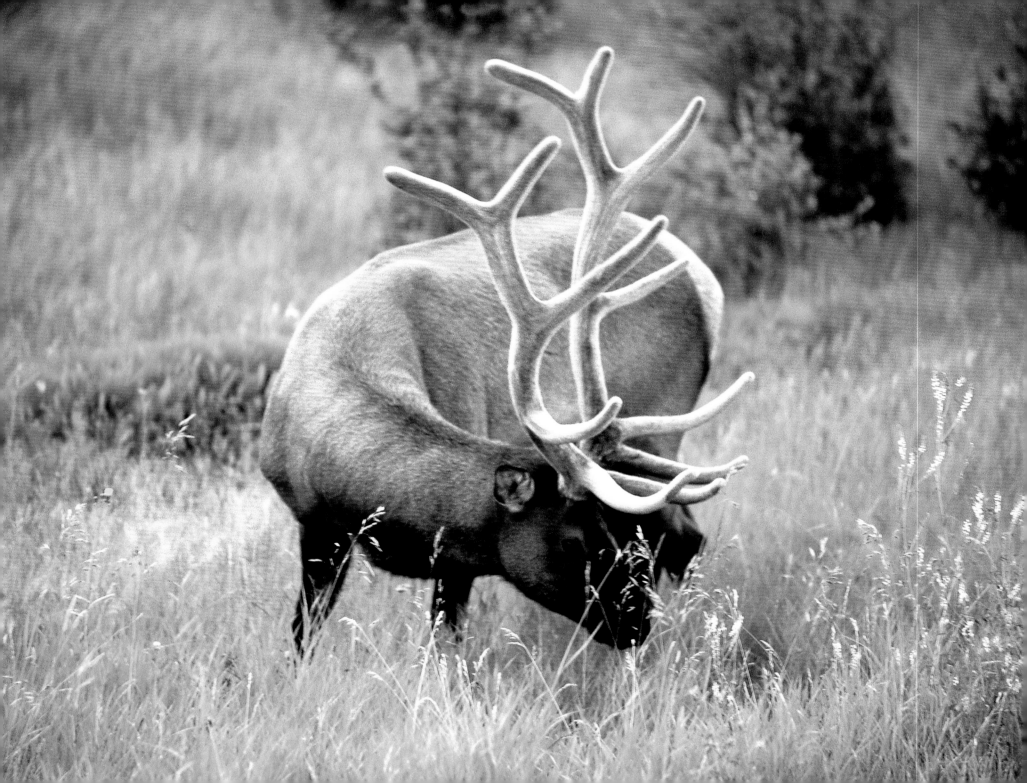

do not, however, wish to even suggest placing elk in any type of unnatural arrangement to be admired. They are handsome and strong, very protective of their young and tough survivors in adverse conditions. The males have the almost unbelievable phenomenon of shedding and replacing their very large antlers each year. It is not uncommon for them to retain their head gear until March. Then, after dropping the antlers, they start growing skin covered ones that will fully mature in late August! It was at this time when the pictures of the two bulls were taken.

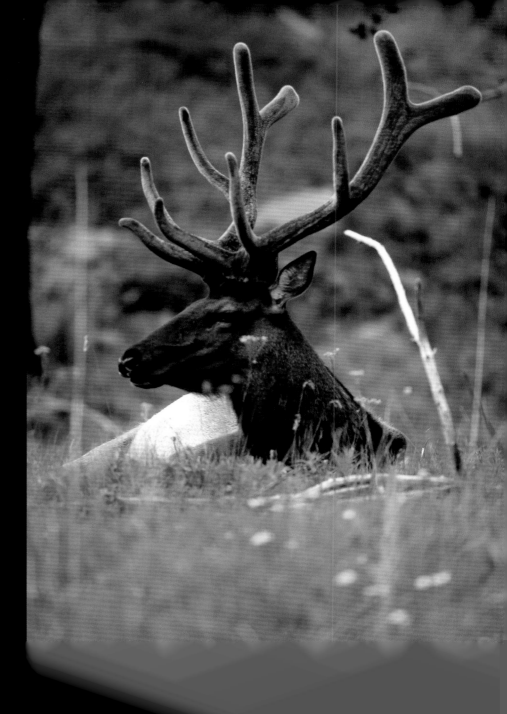

As explained earlier, wild-ranging cats are difficult to find in the daytime. Lions are definitely in this category.

It was a fun experience to take this photograph of a mother mountain lion and her three two-year old kits. Game managers were aware of them also and had designated a location in some trees beyond which no one should trespass. The problem was, though, the distance to the cave den was probably 400 yards away and it took a lot of telephoto and enlarging to get a legible print at all. The game managers had been observing the activities of this family for several months and noticed that they would take, on average, one elk, deer or sheep each week.

The other lion picture where he is looking distressed was taken after dogs had "treed" him. The dogs were taken away and we left this wild cat to go on his way. The contented lion was taken in a large, natural setting enclosure. A favorite picture of mine!

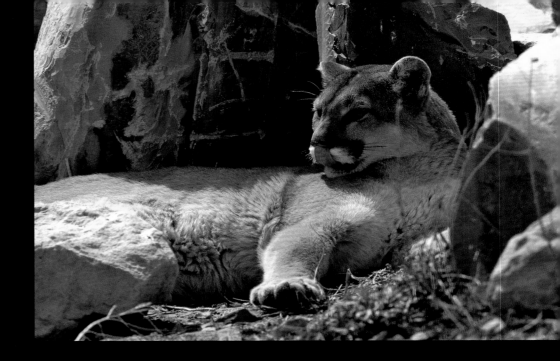

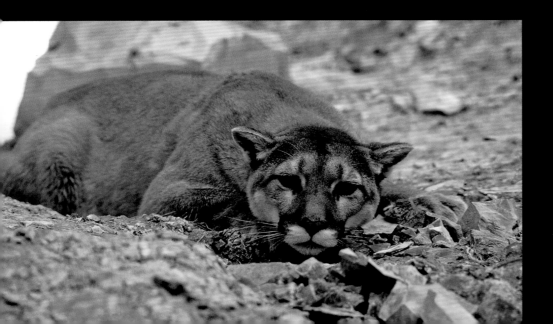

I may have obtained a picture of a wild lion on one occasion had I held a camera in my hands instead of a rifle. I was situated on an elevated hill with my back against an outcropping of rock looking out over a park with a timbered hill behind me. After calling with a rabbit call twice to attract coyotes, I sensed or heard something. Turning around on my knees, I saw a very mature lion loping up toward the timber about thirty yards away. Checking his tracks in three inches of fresh snow, they approached to about twelve feet from where I was sitting! The hair stood up on the back of my neck!

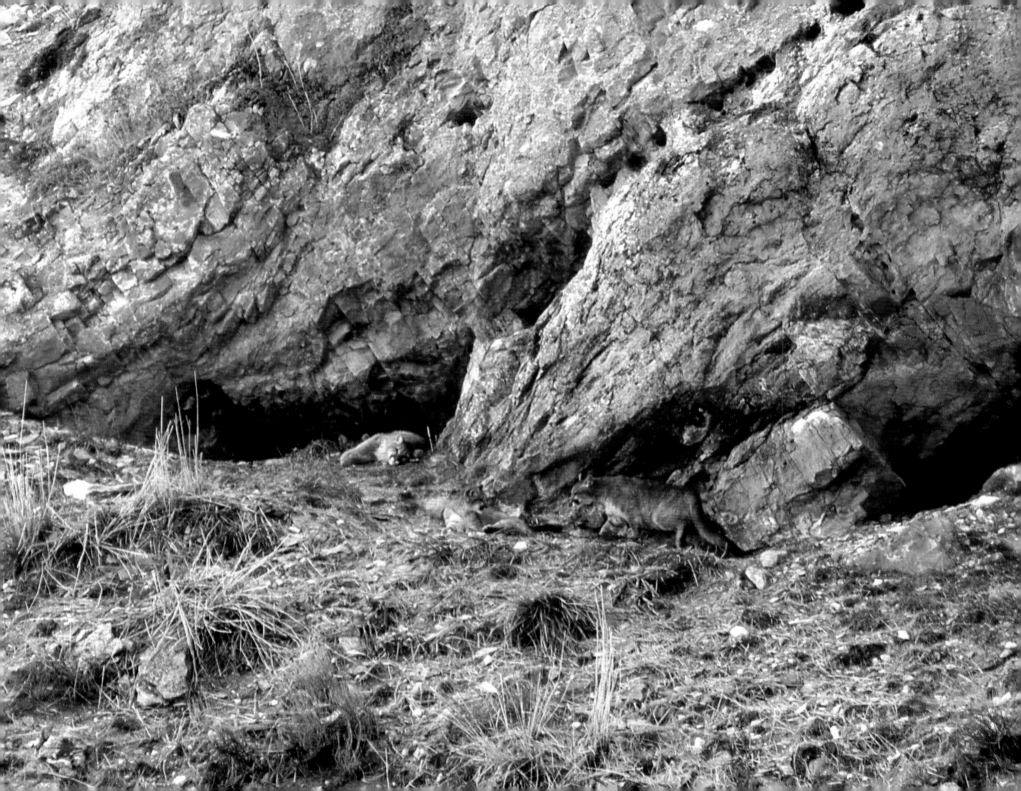

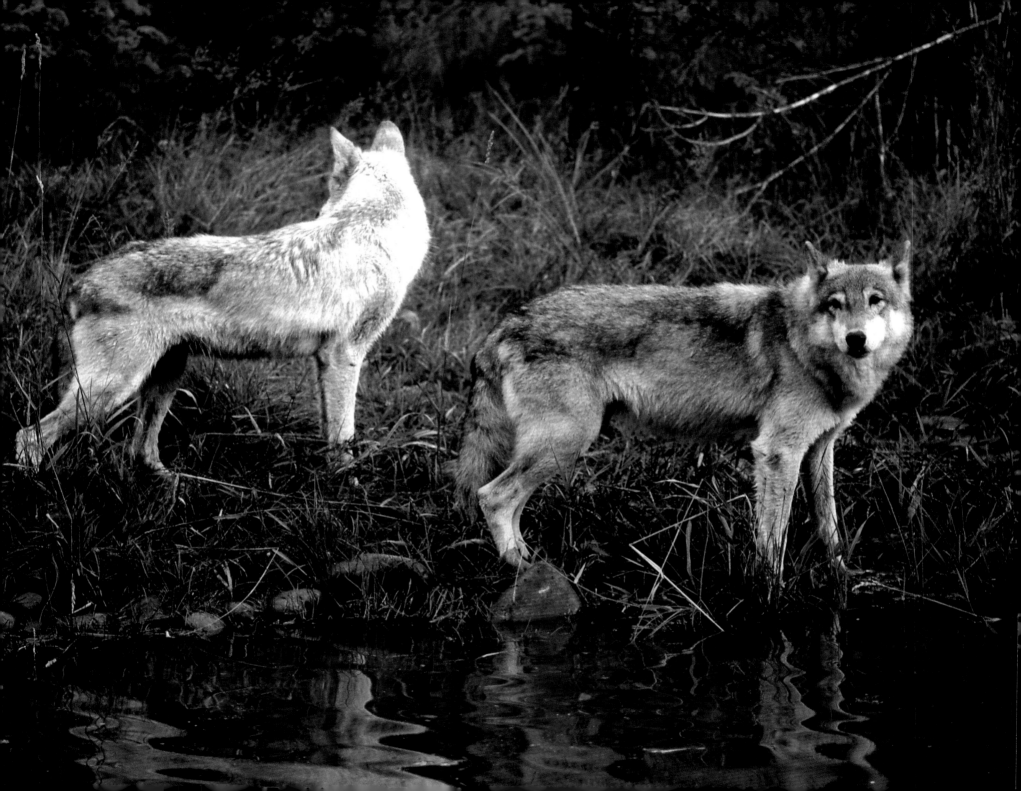

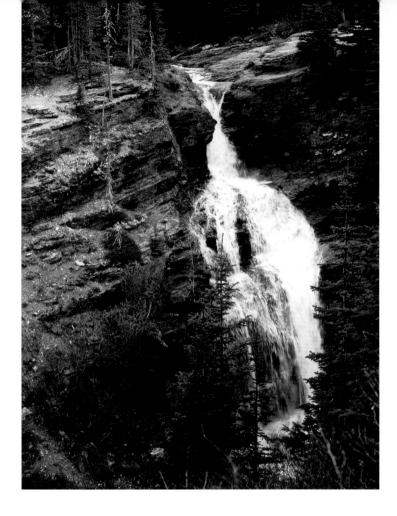

I had taken a couple pictures of wolves in Alaska quite a few years ago but none here until after their introduction in Yellowstone, and then on only two lucky occasions. The first was the earlier photograph with the grizzlies. On the second occasion, I was actually looking for a bull moose that I had previously seen and these two wolves appeared out of nowhere.

Summer is just a fine time to be out in the mountains. Cold streams are finding their way down the mountainsides and fresh new flowers are still blooming along springs.

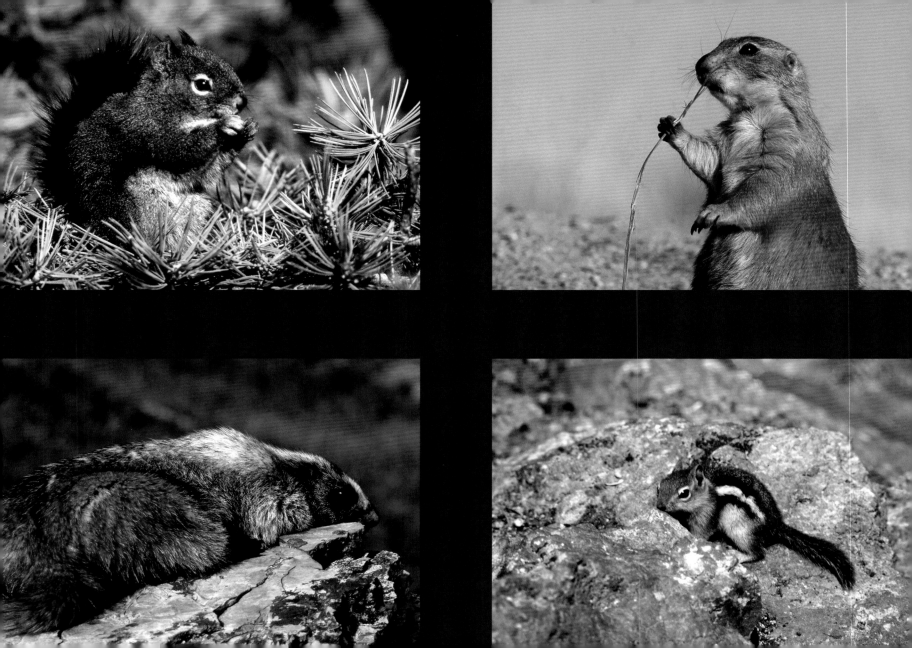

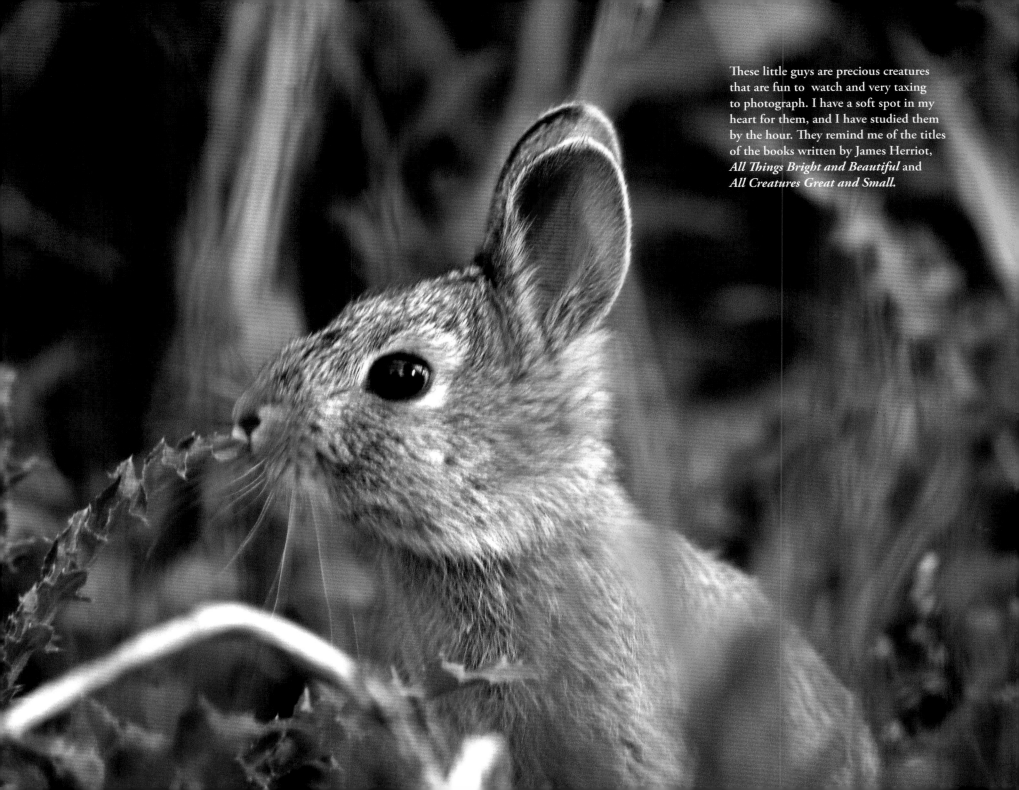

These little guys are precious creatures that are fun to watch and very taxing to photograph. I have a soft spot in my heart for them, and I have studied them by the hour. They remind me of the titles of the books written by James Herriot, *All Things Bright and Beautiful* and *All Creatures Great and Small.*

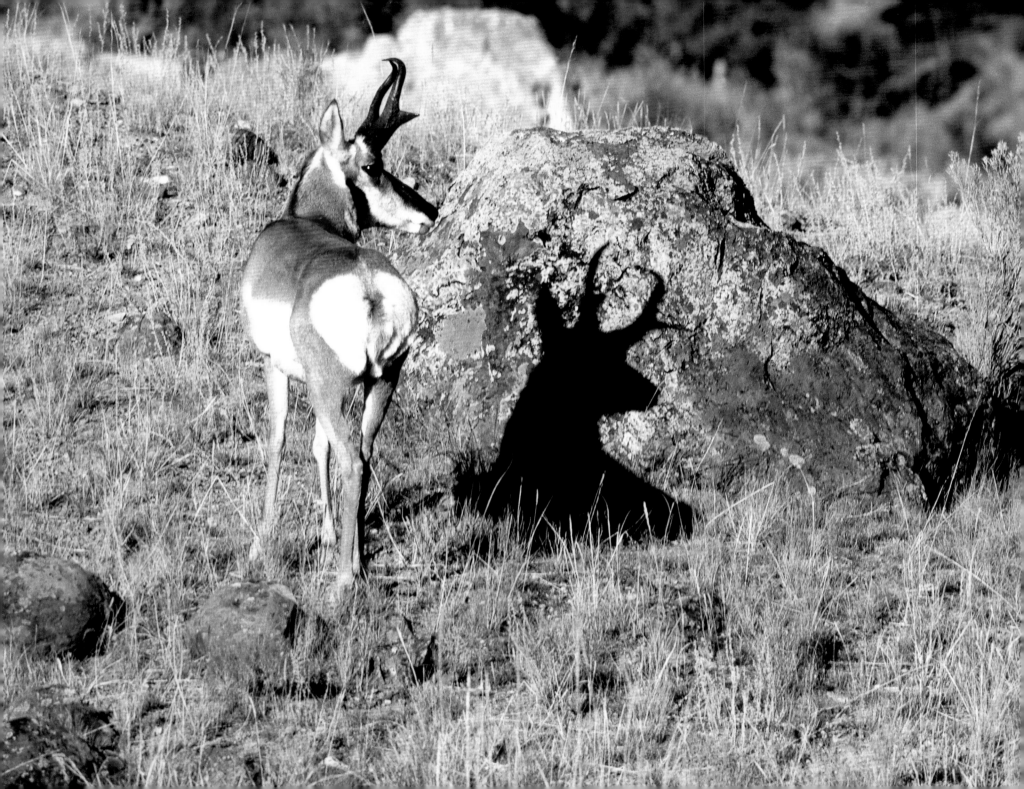

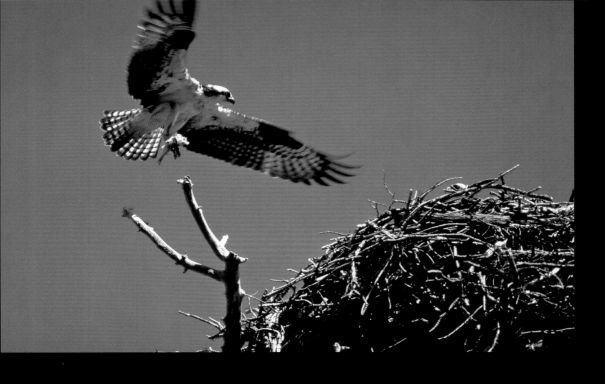

Birds are caring for their young, there are amusing sights at midday such as the antelope checking out his shadow.

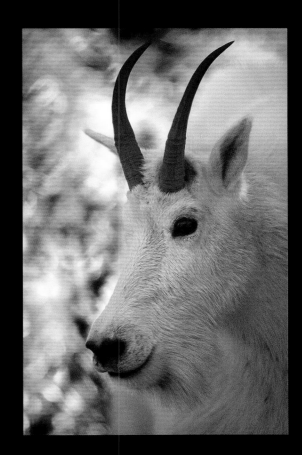

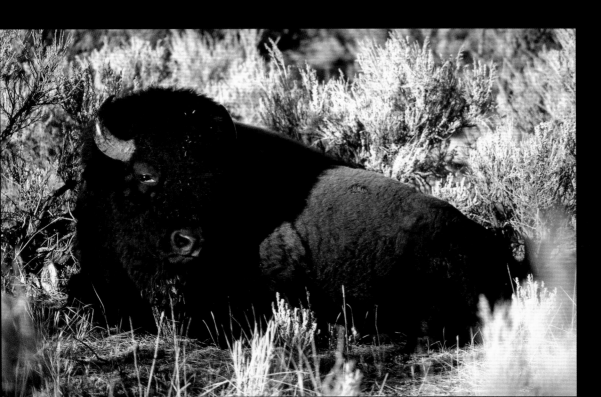

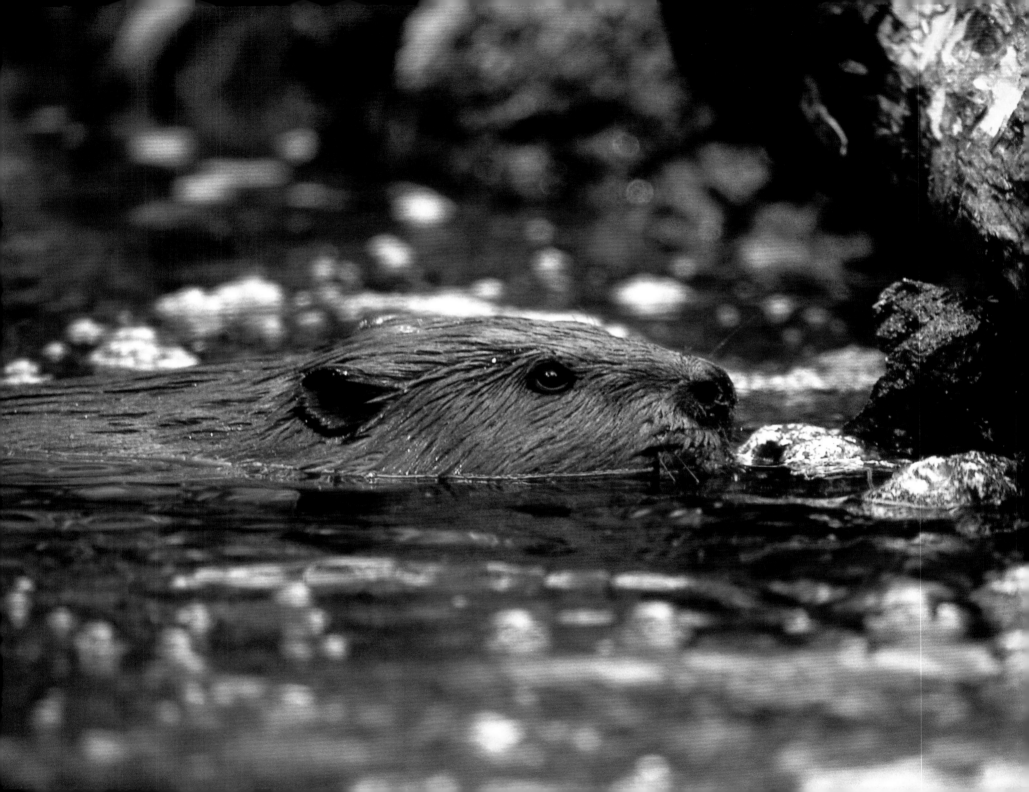

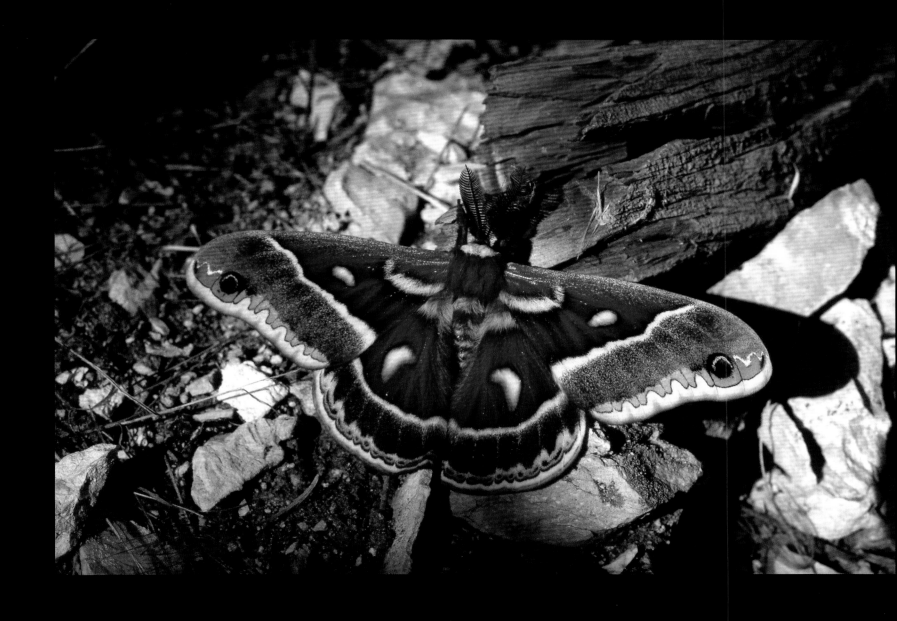

Beavers are a difficult little animal to photograph because they do most
of their work during the night. This one finally made the decision to do
some repair on its dam during daylight and got caught!

The moth makes a handsome picture, and I remember reading where
that type of insect has markings resembling eyes to ward off predators.
A search in the library did not reveal the exact name of this particular one.

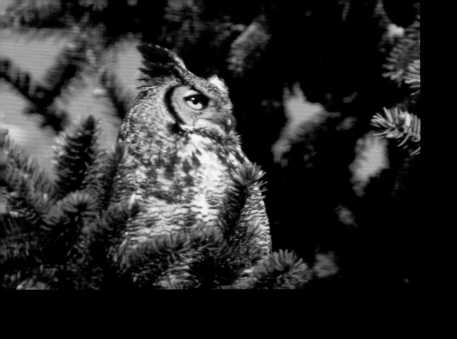
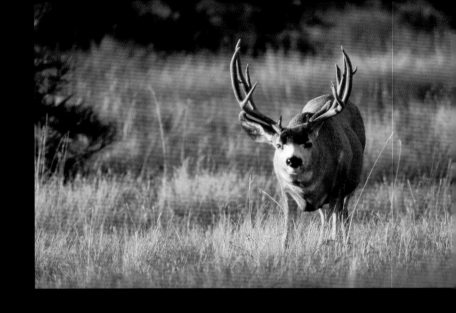

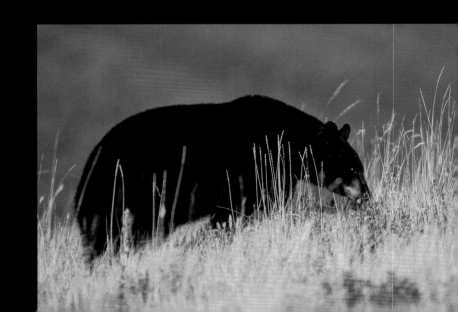

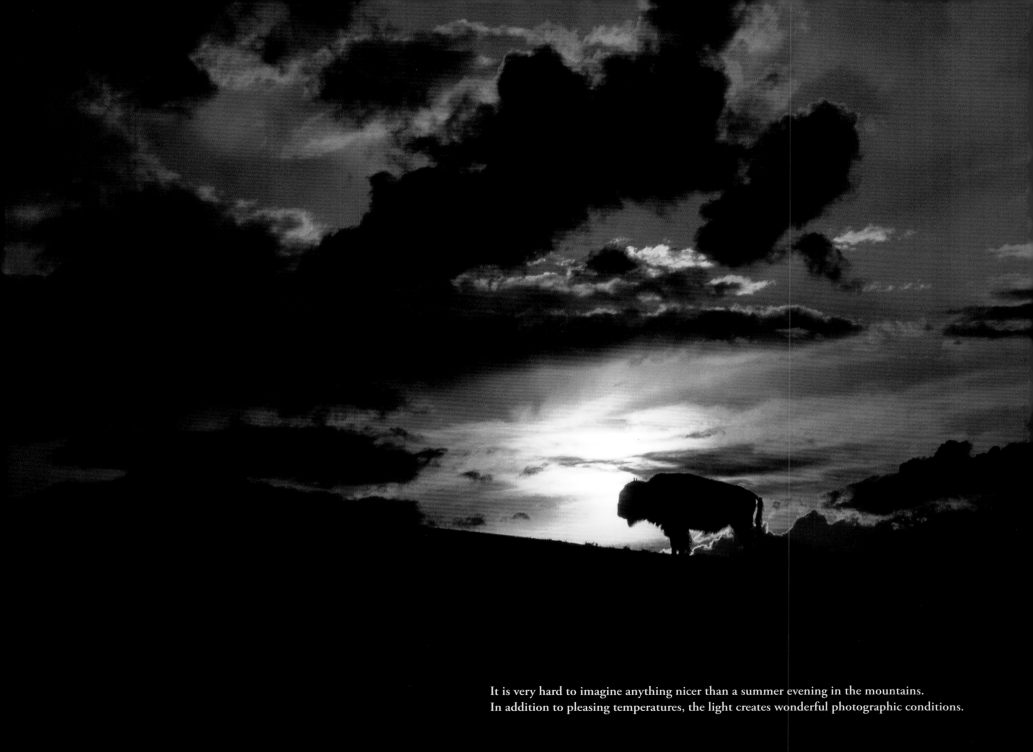

It is very hard to imagine anything nicer than a summer evening in the mountains.
In addition to pleasing temperatures, the light creates wonderful photographic conditions.

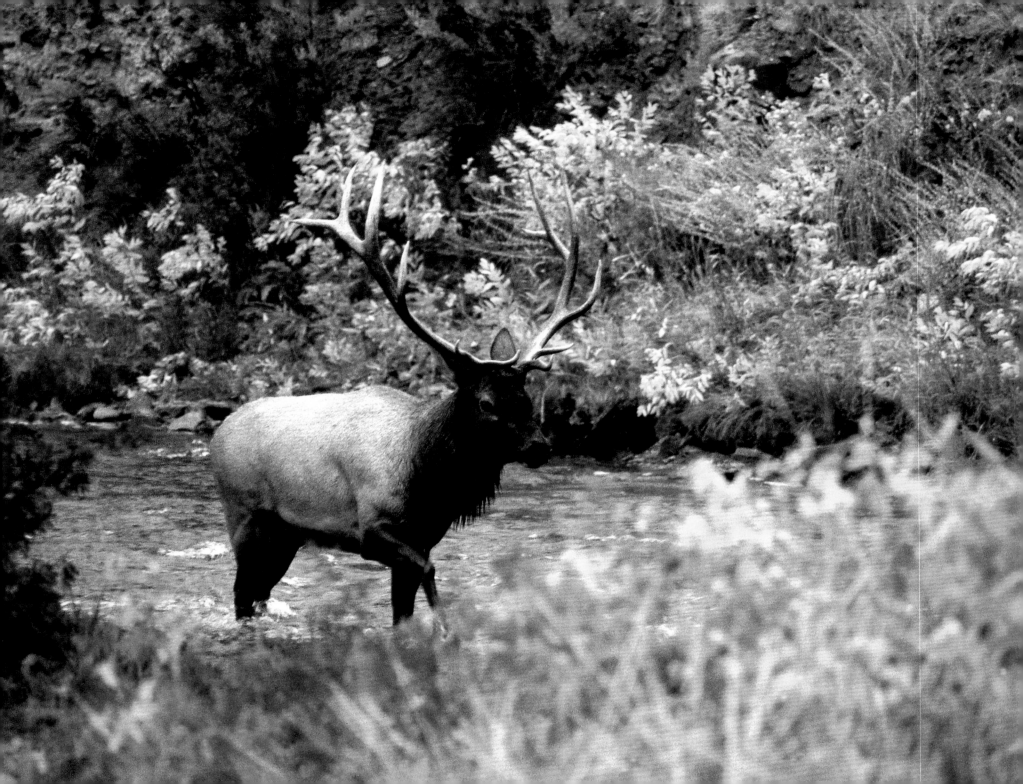

Autumn

The animals are in their absolute prime in both conditioning and appearance—they are beautiful

THE FALL, FROM A WILDLIFE PHOTOGRAPHER'S PERSPECTIVE, is unquestionably the most exciting and productive season of the year. This is the mating season, known as the "rut," for almost all the ungulates. The majority are at their peak in September, but some, like the deer families and goats, breed as late as November. The breeding season is in concert with the length of each species's gestation period, and all are scheduled to give birth in late May or early June.

DURING THIS TIME THEY ARE ALSO ABSORBED in their business of mating and less likely to care about the presence of humans. It is truly the dominance of the fittest to pass on the genes for future generations.

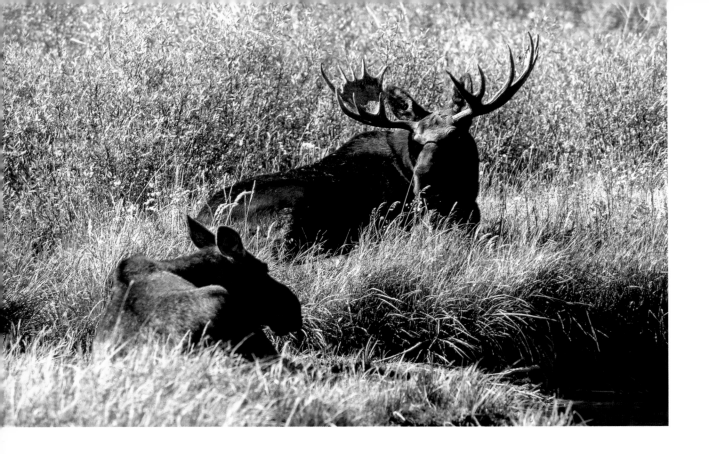

Unlike elk, bull moose do not bugle, or make any distinct sound, during the rut. The bull opposite is simply raising his lip to enhance his smelling ability to test if a female is in etrus. As surprising as it may seem, a cow moose will emit a wailing sound to announce her interest in mating. I have only observed that phenomenon twice, and both times it was difficult to decide what the noise was until it dawned on me, hey, that's a cow moose!

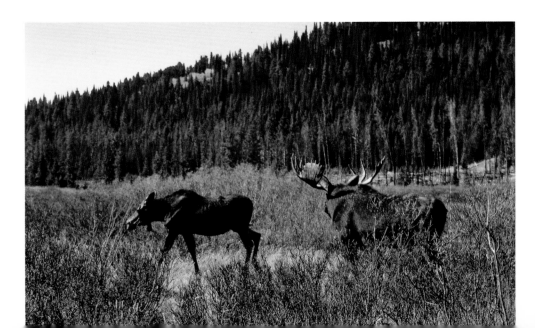

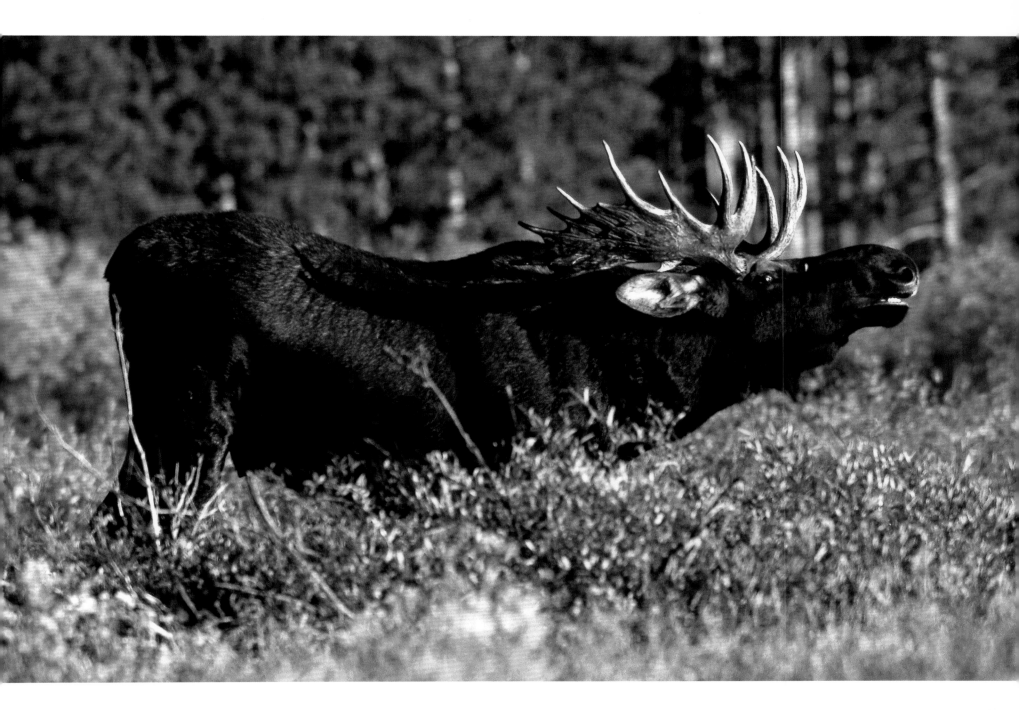

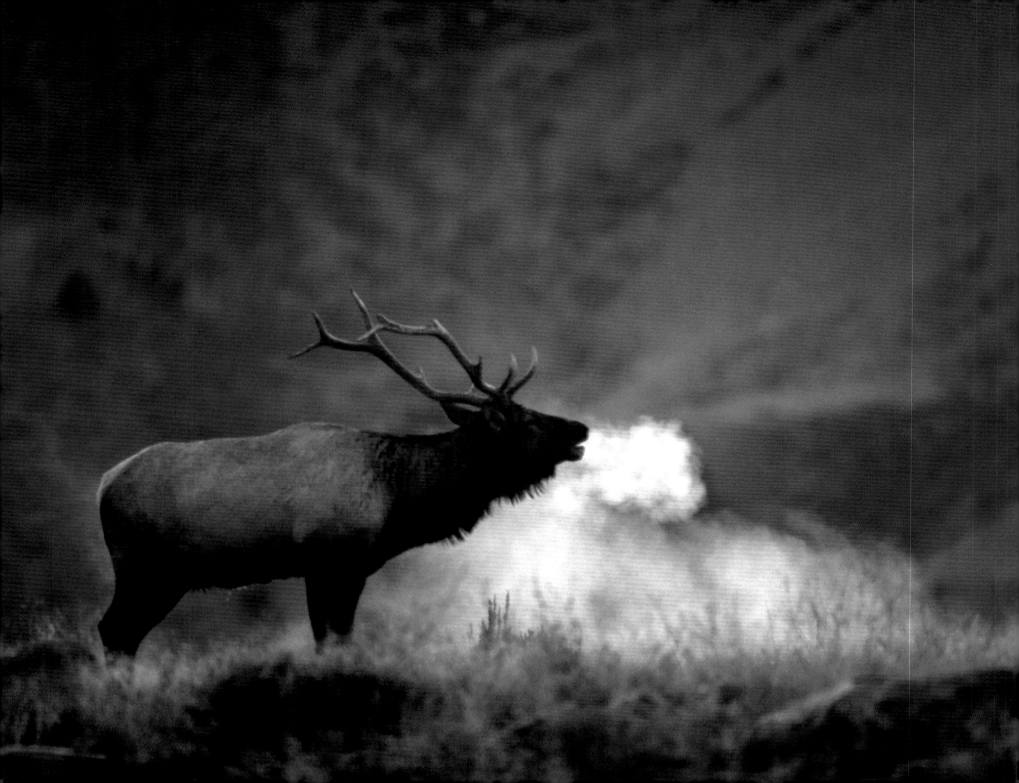

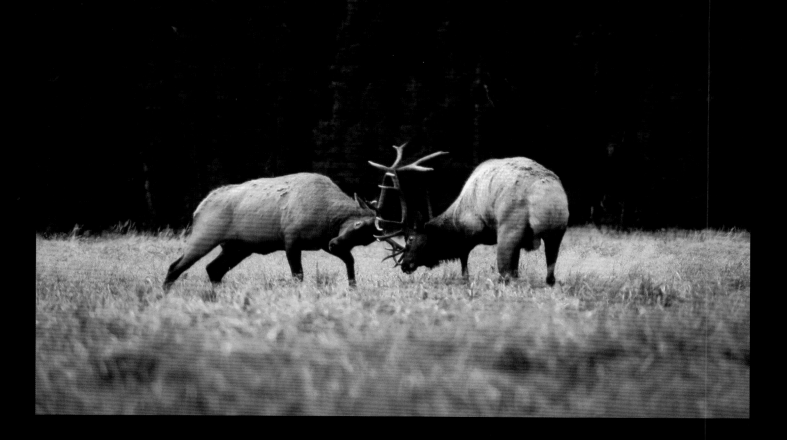

Elk are fairly frequent combatants in their quest for
dominance. It is also somewhat common for them
to inflict serious injury on one another. One of the
most brutal encounters that I have witnessed was on
a morning too dark to photograph, but I captured the
aftermath of a very exhausted bull that I assumed to
be the victor of a fierce battle, although he had broken
off parts of both antlers in the process.

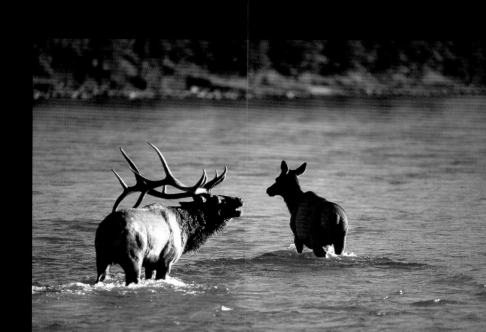

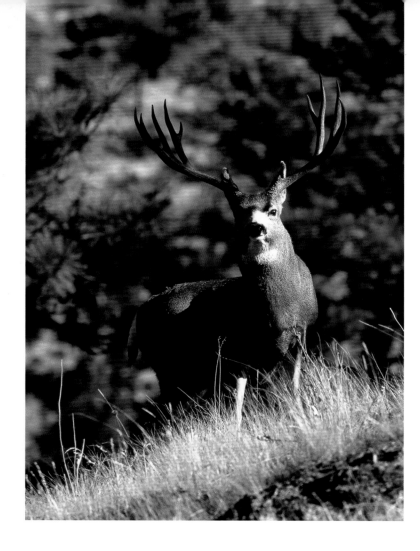

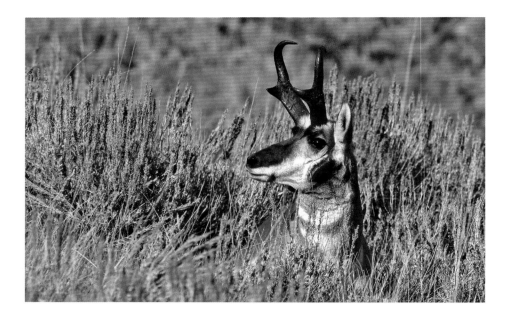

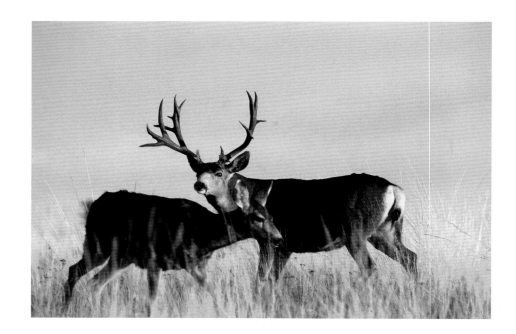

Deer, even though they are generally timid and demure, will also tangle in a struggle for dominance. As a matter of fact, this group of animals may suffer the most fatalities of any species during combat. All of us have seen evidence of this in pictures reflecting locked antlers and, sadly, dead animals of one or both. I have personally seen only one case of mule deer bucks fighting, and it was wicked but I was unable to record it. I have seen whitetails spar quite innocently, but they, too, will occasionally inflict bodily harm.

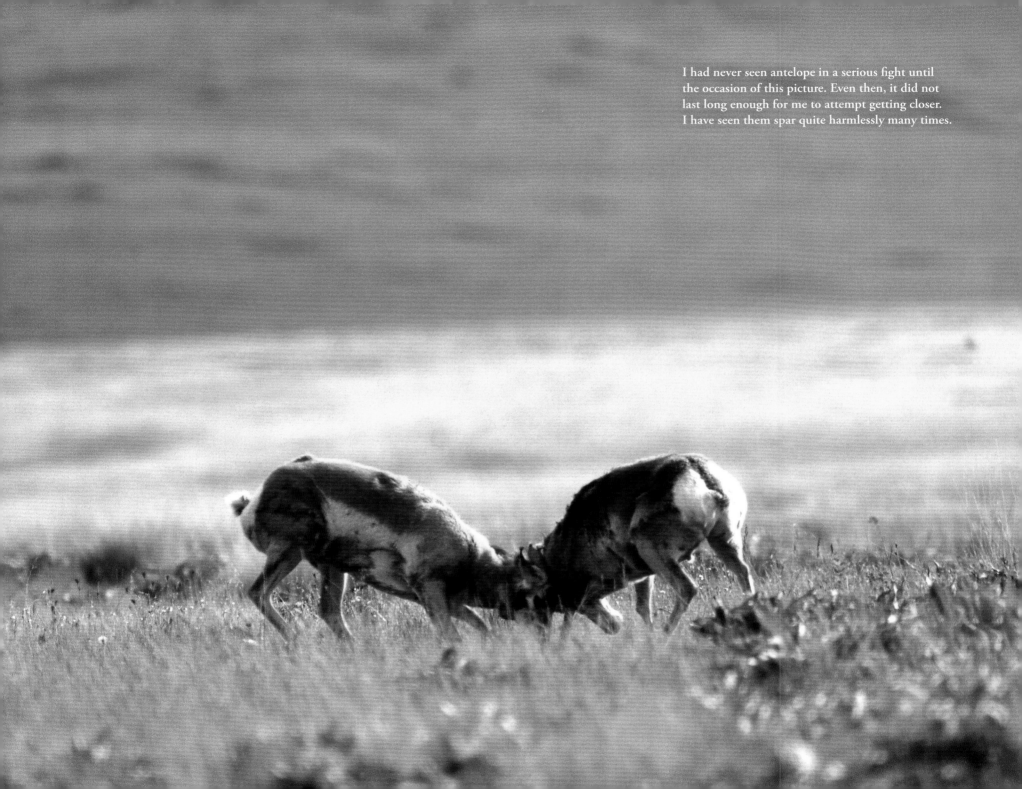

I had never seen antelope in a serious fight until the occasion of this picture. Even then, it did not last long enough for me to attempt getting closer. I have seen them spar quite harmlessly many times.

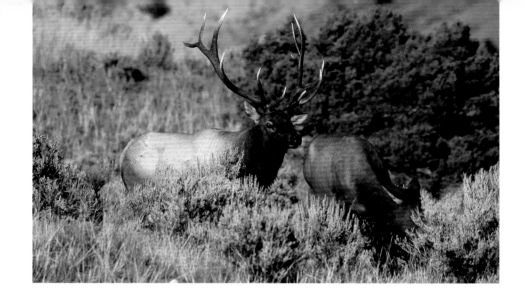

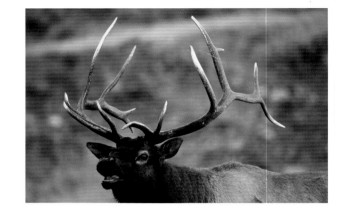

The ungulates shown in this section of the book, primarily depict the mating activities during the fall season. Probably the biggest attraction is a bull elk bugling, which is peculiar only to this species. Other antlered males related to elk in other parts of the world also make a similar sound.

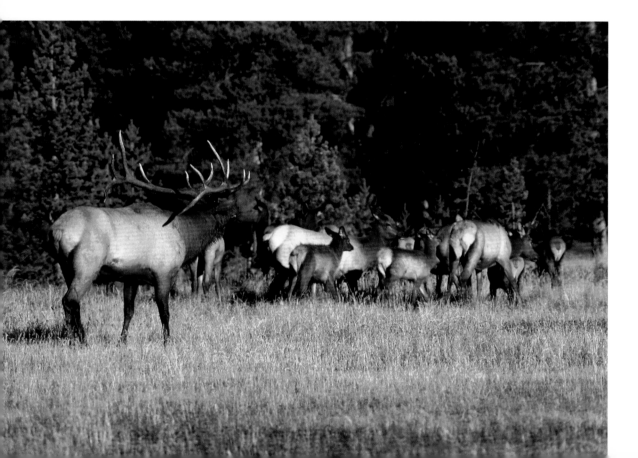

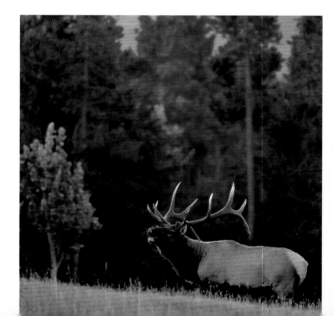

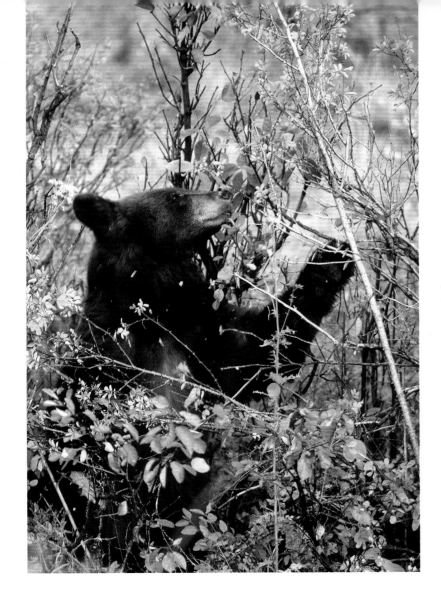

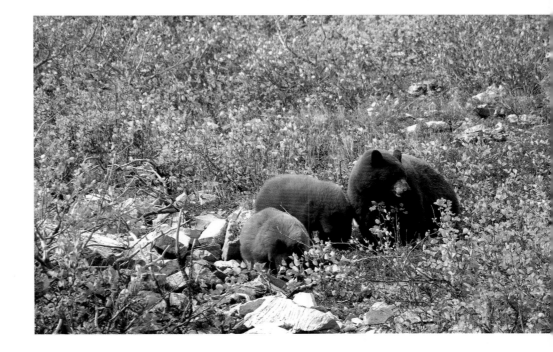

I suspect black bears do occasionally confront each other, but I have not actually seen them do so. This, of course, is not their mating season. What they are doing, however, is stoking up on as much food as they can and therefore, exposing themselves more during daylight hours, which is fortunate for photographers looking to take their pictures.

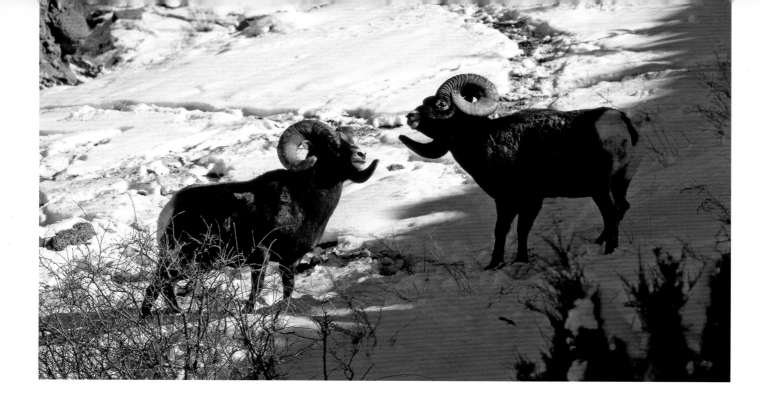

Bighorn sheep are aptly named because the males use those massive horns quite often to confront and fight each other. The series of ram pictures reflect the challenge, the flaunting by the victor, and the combat.

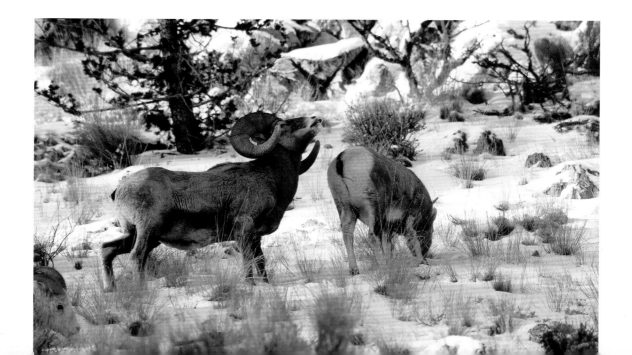

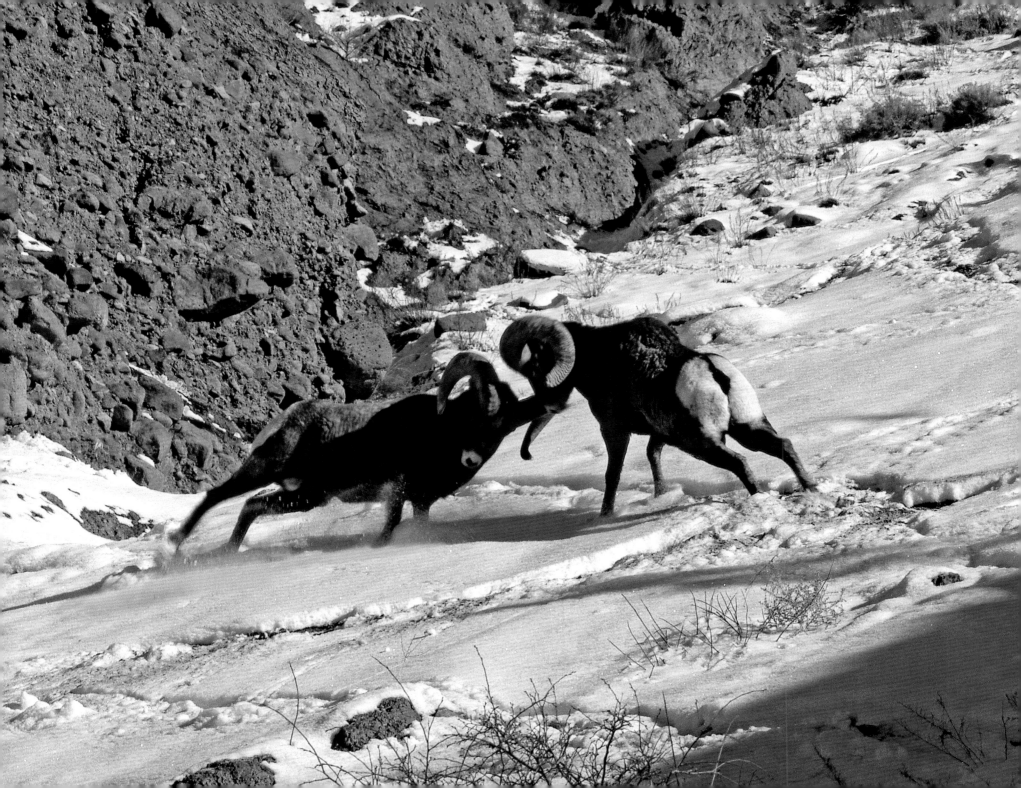

It has been a great ride for me and I hope you have enjoyed the book.

It has been interesting for me to review photographs taken over a span of forty years. As an exercise in reminiscence, I was actually surprised to recognize the location and circumstance of almost every image. There was also the attempt to choose the most technically correct and pleasing for you to peruse.

Sometimes, it seems to me, that I sound like this was my full-time vocation when, in fact, for the first thirty-five years or more, I was very involved in another occupation with absolutely no relation to photography.

What this hobby did was offer a great deal of enjoyment and relaxation. It also allowed me to spend time in this beautiful country of ours and especially with our wildlife, which has been a passion of mine since I was a kid.